JAPANESE PORTRAIT SCULPTURE

Japanese Arts Library

General Editor
John Rosenfield

With the cooperation and under the editorial supervision of:

The Agency for Cultural Affairs of the Japanese Government
Tokyo National Museum
Kyoto National Museum
Nara National Museum

KODANSHA INTERNATIONAL LTD. AND SHIBUNDO
Tokyo, New York, and San Francisco

Japanese Portrait Sculpture

Hisashi Mōri

translated and adapted by

W. Chie Ishibashi

Distributed in the United States by Kodansha International/USA Ltd., through Harper & Row Publishers, Inc., 10 East 53rd Street, New York, New York 10022; in Europe by Boxerbooks Inc., Limmatstrasse 111, 8031 Zurich; and in Japan by Kodansha International Ltd., 2–12–21 Otowa, Bunkyo-ku, Tokyo 112.

Japanese Portrait Sculpture was originally published in Japanese by the Shibundo publishing company, Tokyo, 1967, under the title *Shōzō chōkoku,* as volume 10 in the series *Nihon no bijutsu.* The English edition was prepared at Kodansha International, Tokyo, by Saburo Nobuki, Takako Suzuki, and Michael Brase.

Published by Kodansha International Ltd., 2–12–21 Otowa, Bunkyo-ku, Tokyo 112 and Kodansha International/USA Ltd., 10 East 53rd Street, New York, New York 10022 and 44 Montgomery Street, San Francisco, California 94104. Copyright © 1977 by Kodansha International Ltd. and Shibundo. All rights reserved. Printed in Japan.

First edition, 1977.

LCC 76–9353
ISBN 0–87011–286–4
JBC 1371–785600–2361

CONTENTS

Japanese Art Periods

Prehistoric		–537
Asuka		538–644
Nara		645–781
Hakuhō	645–710	
Tempyō	711–81	
Heian		782–1184
Jōgan	782–897	
Fujiwara	898–1184	
Kamakura		1185–1332
Nambokuchō		1333–91
Muromachi		1392–1572
Momoyama		1573–99
Edo		1600–1867

Note: This table has been provided by the Agency for Cultural Affairs of the Japanese Government.

ILLUSTRATIONS

A Note to the Reader

Japanese names are given in the customary Japanese order, surname preceding given name. The names of temples and subordinate buildings can be discerned by their suffixes: *-ji, -tera, -dera* referring to temples (Tōshōdai-ji; Ishiyama-dera); *-in* usually to a subtemple attached to a temple (Shōryō-in at Hōryū-ji); *-dō* to a building with a special function (Miei-dō); *-bō* and *-an* to larger and smaller monastic residences, respectively (Gokuraku-bō; Ryūgin-an).

INTRODUCTION

Before attempting to analyze and evaluate the body of works classified as Japanese portrait sculpture, it is necessary to clarify the meaning of the term "portrait." John Pope-Hennessey, in the preface to his volume *The Portrait in the Renaissance,* defines portraiture as the "depiction of the individual in his own character." One can presuppose that the present-day reader understands the phrase "individual in his own character" since the Renaissance tradition of individualism still survives in modern attitudes concerning individuality, character, and personality. When this definition is applied, however, to the portraiture of periods and places having little or no relationship to the cultural traditions of the modern West, no such correspondence of attitude can be assumed between the creator of the portrait and the present-day beholder; for portraiture, perhaps more than any other form of visual art, reveals the self-conception of the culture that produced it. To interpolate modern Western concepts of personality into a portrait before ascertaining the extent to which the culture that produced it subscribed to these concepts is not only to misunderstand the work of art, but also to misunderstand the culture.

A portrait may be apprehended on three levels. The first is on the formal plane where it is judged primarily as a work of art, compared stylistically to other related artistic productions, and placed within its proper niche in the formal evolution of works of its kind. The second level concerns the relationship between the portrait and its subject; that is to say, its identification—the extent to which it faithfully communicates the physical appearance of the subject, and the manner in which this descriptive process is executed. These first two dimensions of appreciation may contradict each other, for they are essentially at cross-purposes; G. M. A. Hanfmann, in his analysis of Roman portraiture, remarks upon this basic contrast in viewpoint: "The historian asks for the most faithful portrait of Augustus; the art historian for the best portraits in the Augustan style."* The third level of appreciation is that of the exegetical, where the observer may be able to discern, from the nature and identity of the subject and the style of execution, the character of the culture by and for which

* *Observations on Roman Portraiture,* p. 20.

the portrait was created. All three levels must be taken into consideration when analyzing a portrait in order to understand it as a complete entity.

Keeping these thoughts on the general nature of portraiture in mind, one can begin to focus on a specific area—in this case that of Japanese sculpted portraits, a noteworthy body of works that has yet to be given full consideration among the world's significant portrait traditions.

Japanese portrait sculpture developed in a Buddhist context and never completely divorced itself from that religious setting. From the beginning, the majority of the subjects portrayed were religious personages, whether legendary or historical. Even when lay subjects began to appear in the latter part of the Kamakura period, their portraits were enshrined in temples with which they were closely affiliated.

The intimate connection between Buddhism and portrait sculpture creates complications in the very definition of portraiture, for the association of portraits with Buddhist liturgy blurs the distinction between historical and imaginary portraiture, and between portraits and objects of worship. Even among Japanese scholars there is disagreement concerning the definition of a portrait: there are those who assert that any work representing an individual personage, whether mythical or historical, can be classed as a portrait; others hold that only depictions of historical personages whose representations are in some way grounded in personal observation can be termed portraiture. The genre itself defies absolute categorization. In attempting to distinguish between portraits and objects of worship, it is immediately apparent that there are numerous portraits that serve as objects of worship. In attempting to differentiate between mythical and historical personages, one is faced with representations of historical personages produced so long after their deaths that they may as well represent legendary figures. And if one attempts to establish stylistic criteria for differentiating between depictions of historical personages and representations of figures from legend, it is soon discovered that historical figures are at times rendered according to the canons regulating the proportions of images of Buddhist deities, while mythical figures may be treated in a realistic manner. Indeed, the development of Japanese portrait sculpture is so closely allied to the Buddhist establishment and Buddhist art that an understanding of the relationship between them is absolutely essential to the appreciation of the sculpted portrait.

Whatever form portraiture may take—whether specific physical traits or more general features are stressed, whether overt expression or subtle nuance is preferred —it would seem essential, if portraiture is to exist, for the culture involved to possess an affirmative attitude toward physical form. Yet, from its beginnings, Buddhism has had a negative outlook toward the material world and the human body. In the *Vimalakīrti-nirdeśa-sūtra*, dating to the second century A.D., the sage Vimalakīrti delivers an eloquent sermon on the infirmities of the human flesh:

Gentlemen, the human body is transient, unstable, unworthy of confidence and

weak; it is without solidity, is perishable, of short duration, is filled with sorrow and unease, filled with ailments and subject to change. . . . The wise man trusts it not.*

When the human body is held in such low esteem, the only reasonable rationale for the physical depiction of a specific individual would be that the production of the image of a venerated monk or devotee might help to further the spread and understanding of the Buddhist faith. Such a practice would be permissible according to the concept of *upāya kauśalya* or "skill in means," the teaching method of the historical Buddha Śākyamuni, who used different approaches according to the needs and limitations of the individuals seeking guidance.

The monk portrait, probably derived from the strong tradition of arhat representation in China and transmitted to Japan, was surrounded by a strongly devotional atmosphere and invested with great religious significance, a physical reminder of the achievements of the subject and his position in the chain of transmission of the Buddhist law. In such a setting it was natural for a portrait to be commissioned by the disciples of a monk shortly after his death in order to commemorate his memory; it was not until the later stages of Japanese Buddhism that portraits of living subjects came to be produced, or that portraits were commissioned by the subject himself for purely personal reasons.

With an understanding of the general religious ambience of Japanese portrait sculpture, one can attempt to evaluate its degree of success as true portraiture. Once Pope-Hennessey's definition of true portraiture as the "depiction of the individual in his own character" is accepted, a term is then needed for those works that fall into the more general category of portraiture but yet do not satisfy the requirements of a true portrait. It is here suggested that these works should be described as "attributive portraits," that is, representations of specific personages characterized not by an attempt to penetrate the psychology of the subject but by an identification or depiction of the subject through his accepted external attributes.

It is of interest to note that the term "true portraiture" is most applicable to Japanese portrait sculpture in the following two situations: when the character and achievements of the subject portrayed are of primary importance to the transmission of religious beliefs, especially apparent in the representation of Zen monks (see pls. 3, 83–84, 85, 120–22); and when sculpted portraits in Japan are subject to the influence of realistic currents in Chinese art, as in the case of the statues of Ganjin (Chien-chen) (pls. 5–6), and Shunjōbō Chōgen (pls. 73, 81). It appears that the further the character of the portrait subject is from serving an essential religious function, and the greater the distance from vitalizing artistic influences that promote realism, the greater the tendency to rely on the attributive qualities of the portrait subject, and the less

* *Vimalakīrti-nirdeśa-sūtra* II: 7–13, trans. Étienne Lamotte. In *L'Enseignement de Vimalakīrti* (*Vimalakīrtinirdeśa*). Louvain : Publications Universitaires, 1962.

the inclination to portray the personality of the individual involved. Intellectually though not aesthetically interesting examples of this phenomenon are to be seen in the group of statues of the fifteen generations of the Ashikaga shoguns in the Tōji-in in Kyoto, the figures of Toyotomi Hidetsugi and the nun Nichihide in the Zenshō-ji in Kyoto, and the image of Fujioka Chōbee in the Kyoto Fukutoku-ji, all of which date to the period of decline of Buddhism from the sixteenth to the nineteenth centuries, and all considerably smaller than life-size, highly stylized, and doll-like.

The application of Western art-historical methods to the study of Japanese religious art is an approach now practiced by many Japanese scholars. That is to say, paintings and statuary once considered purely as religious objects have now come to be studied as works of art and subjected to stylistic, iconographic, and iconologic analysis. The author of this volume is just such a scholar, and this translation endeavors to retain the spirit of his analytical approach.

A problem arises, however, in the meaning given to certain descriptive terms, which when used by the author possess different connotations from those which have accrued to them in Western art history. For example, the term *shajitsu,* literally "to copy reality," and usually translated "realism" or "naturalism," is applied in the text to any work on which realistic techniques were employed. To the Westerner, whose artistic traditions have conditioned him to different nuances in naturalistic imagery, the disparity between the terms "realism" and "realistic technique" is immediately apparent: the works of the great Greek sculptors of the fifth century B.C. are not considered realistic simply because they are not treated in an abstract manner; rather, they are considered idealistic in overall conception though rendered in realistic technique. Furthermore, in Western terminology, "idealism" related to the perfection of human proportions, while, in a Buddhist context, "idealism" refers to the abstract canonic proportions regulating the representation of Buddhist deities. Therefore, in translating the descriptive vocabulary of the Japanese text, potentially confusing terms have been adjusted to meet the expectations of the Western reader.

Although the subjects of the portraits discussed in this book belong to the historical memory of the Japanese, the majority is totally alien to the Western reader. Therefore, an appendix of frequently depicted historical personages has been included, and, wherever necessary, brief biographical accounts have been inserted into the text. The original sequence of the author's presentation has been preserved, but certain additions and deletions have been made with the author's knowledge, and material rearranged within chapters for the sake of clarity and precision.

I would like to thank Mr. Shozui Toganoo of the Museum of Fine Arts, Boston, for his help in interpreting some specific iconographic details, and Professor Masatoshi Nagatomi of Harvard University for his aid in defining a number of Buddhist terms. I am also greatly indebted to Professor John Rosenfield of Harvard University for his ready advice, assistance, and encouragement.

W. Chië Ishibashi

JAPANESE PORTRAIT SCULPTURE

1

BUDDHISM AND THE PORTRAIT

The mainstream of Japanese sculpture is occupied by statues depicting Buddhist subjects, and the history of its evolution necessarily centers on such works. Following a course of development roughly parallel to that of Buddhist art, now intersecting and now diverging, is the art of portrait sculpture, which deserves consideration as a separate expressive genre.

The content of Japanese portrait sculpture is highly complex: there are portraits that reflect an outlook similar to the Western concept of individualism, but there are also statues, regarded as objects of worship, that exhibit only vestigial traces of the qualities that were characteristic of the individual subjects, the depiction of which is essential to true portraiture. These last are portraits of venerated monks and founders of religious sects that are often strongly influenced by the canons regulating Buddhist images in general. Both the religious beliefs reflected in the choice of the subjects of such portraits and the historical and social context in which their statues were created determined the extent to which influences from Buddhist art affected the representation of such personages. In numerous examples the individual character of the subject is of greater importance than a formal correspondence with images of Buddhist deities, and in such statues the characters and physiognomies of the subjects are admirably delineated. Portraits of laymen, completely free from the influences of religious art, are subject to a different tradition. In attempting to ascertain the extent to which portraiture has been influenced by Buddhist art and to what extent Japanese portrait sculpture maintains its integrity as true portraiture, not only will the specific character of Japanese portrait sculpture become apparent, but also its relationship to the history of Japanese sculpture in general.

Although the portraits of venerated monks, which form the body of Japanese portrait sculpture, have come to be appreciated as objects of aesthetic value, their devotional character cannot be disregarded. The original purpose behind the creation of these statues is frequently commemorative. More often than not, these are works commissioned by the followers of the subject, shortly after his death, out of a wish to perpetuate his memory, and in the end they often become objects of worship. From a purely aesthetic point of view, this devotional aspect of Japanese portrait sculpture

may be considered tangential, but from an art-historical view it cannot be ignored, for it has a direct effect on the forms of the works themselves.

In an attempt to reconstruct the religious ambience of sculpted portraits, four aspects relating to portrait sculpture will be discussed. First is the manner in which portrait statues were housed and displayed, indicative of the depth of veneration accorded to them. The relationship between the subject of the portrait and the hall in which his portrait was preserved not only sheds light on the nature of the activities performed within the temple complex itself, but also provides insight into the life and career of the subject.

The remaining three points deal with religious practices that influenced the forms and techniques of the statues themselves. First, sculpted portraits were provided with large hollow interiors to accommodate articles either of a general religious nature, such as Buddhist texts or prayer formulas, or of a more personal nature, such as objects relating to the spiritual career of the subject. Both kinds of deposited objects served to underscore the religious and commemorative function of the portrait statue. Second, the devotional aspect of sculpted portraits is illustrated by the practice of rendering certain portraits as if unclothed in order that the devotee might clothe the statue as an act of piety. Last, in some rare cases the statue was provided with the actual hair of the subject, or, more frequently, devotees would donate their own hair.

Structures Housing Portraits

Within a temple complex a hall alternately called *eidō* (portrait hall), *kaizandō* (founder's hall), or *soshidō* (patriarch's hall) was often dedicated for the purpose of housing portraits of venerated monks. Although it seems that similar structures had existed as early as the Nara period (645–781), it was not until the Heian period (782–1184) that separate portrait halls were built in most temple complexes and became the locale of devotion for both monks and laymen. Particularly during the following Kamakura period (1185–1332), in the newly risen Jōdo (Pure Land), Shin, and Nichiren sects,* the whole temple complex came to be focused on the portrait hall, a trend that developed out of a deep reverence for the personalities of the founders of these sects. Ultimately, such veneration caused the portrait hall to be given even greater consideration than the main hall, where the images of the Buddha were enshrined. Although the meaning attached to such halls differed to some extent in the Zen sect, a founder's hall was often built in the headquarters of the sect or subsect. An understanding of these halls helps to clarify the significance of the portraits enshrined within.

The Monastic Residence and the Portrait Hall
The precedents for the Japanese portrait hall are to be found in China. Among the

* See Glossary for these and other terms.

poems of the famous Chinese poet and painter of arhats Kuan Hsiu (832–912), who lived during the late T'ang–Five Dynasties era, there is a work entitled "Passing through the Old Temple of Hsi Pai." In the poem Kuan Hsiu mentions that a portrait of the late monk-poet Hsi Pai, depicting him at work in his study, was placed in the building in which he had once lived. Thus, Hsi Pai's residence had come to be used as a portrait hall after his death, as the place most suitable for recalling the monk as he had appeared during his lifetime. The conversion of residences into portrait halls appears to have been a common practice in China.

This practice had also spread to Japan and gained acceptance. At the Kongōbu-ji on Mount Kōya, headquarters of the Shingon sect of Buddhism, a portrait hall housing an image of the sect founder, Kūkai (774–835), had existed from an early date. This hall was located between the main pagoda and the western pagoda north of the *kondō,* or "golden hall," where Kūkai's residence is believed to have once stood. The present portrait hall, a building with a gently inclined, pyramidal roof, retains a residential atmosphere. Within this structure is enshrined a painting of Kūkai said to be by the monk-painter Shinnyo Hōshinnō, who was the third son of the emperor Heizei (r. 806–9) and had once studied under Kūkai. The painting itself is a secret image never placed on public view.

The cult that formed around the portrait of Saichō (767–882), the founder of the Tendai sect, at the sect headquarters on Mount Hiei, never became prominent, yet a wooden statue of Saichō was nonetheless enshrined in the southern part of the inner sanctuary (the Komponchūdō) of the main temple, and portrait halls of his successors were established within the Hiei complex. The Zentō-in, for example, was once the combined library and residence of the monk Ennin (794–864), where he worked on the sutras and Buddhist ritual implements he had brought back from T'ang China (618–907). After his death in 864, Ennin's portrait seems to have been enshrined in the Zentō-in, thus converting it into a portrait hall. An image of Saichō, Ennin's teacher, may also have once been installed there. The Sannō-in residence (Gotō-in) of the ninth-century Tendai monk Enchin is a similar example. Buddhist sutras and other texts that Enchin himself had brought back from China were secretly kept in his residence. When Enchin died in 891, this building was similarly turned into a portrait hall, and a wooden statue of the monk was installed there.

The oldest of the existing portrait halls in Japan is the Shōryō-in of Hōryū-ji near Nara (pl. 1), dedicated to Shōtoku Taishi (574–622), the prince who founded the monastery and played a fundamental role in the establishment of the Buddhist faith in Japan. The present Shōryō-in was built in 1284, and its style is reminiscent of medieval domestic architecture. On the whole, the building reflects the influence of the cult centered on the image of Shōtoku Taishi installed within (pl. 13), and is a splendid palatial structure. The earlier edifice, erected at the time of the original installation of the portrait of Shōtoku Taishi in 1121, appears to have been a simple structure located in the southern portion of the *higashimuro* (eastern monks' resi-

19

dence). Although it is difficult to imagine that Shōtoku Taishi actually lived on this spot, the detached eastern monks' quarters still exist behind the portrait hall, and thus the custom of founding such halls on the sites of residences seems to be in evidence here as well.

Tōshōdai-ji and Kōzan-ji

It is clear from the preceding examples that many portrait halls were directly or indirectly derived from the residences of the subjects whose portraits were enshrined within. The relationship between residences and portraits can be further seen in the Tōshōdai-ji and Kōzan-ji.

The principal image of the portrait hall of the Tōshōdai-ji in Nara is the famous dry-lacquer statue of the Chinese founder of the Japanese Ritsu sect, Ganjin, or Chien-chen in Chinese (688–763; pls. 5–6). The portrait was made most likely in the spring of 763 just before his death. However, it appears that a portrait hall as such was con-

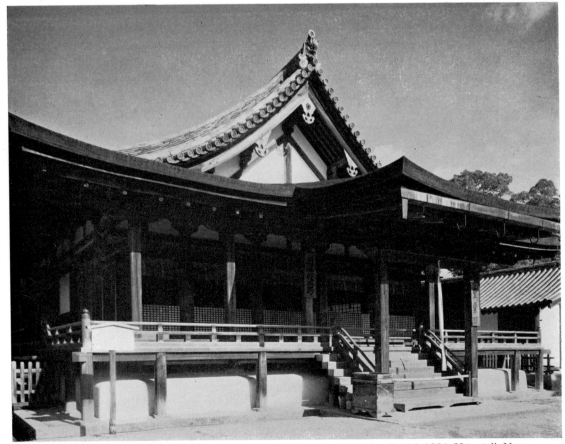

1. Shōryō-in. Oldest existing portrait hall in Japan, dedicated to Shōtoku Taishi. 1284. Hōryū-ji, Nara.

structed in the temple complex only at a much later date. The first recorded evidence of such a structure occurs in the *Shichidaiji nikki* (Record of the Seven Great Temples [of Nara]), written by Ōe no Chikamichi in 1106: "In the corner to the northwest of the *kondō* is a hall three *ken* [1 *ken* = 1.8 meters] to a side and the portrait of the abbot Ganjin is installed there. To the left there is a painting of the monk Nyohō, and to the right a painting of the monk Gijō." Nyohō (Ju-pao) and Gijō (I-tsing) were, respectively, central Asian and Chinese monks, disciples of Ganjin who had followed their master to Japan. Ōe no Chikamichi further elaborates on the exact site of the old portrait hall in his *Shichidaiji junrei shiki* (Private Record of a Pilgrimage to the Seven Great Temples): "It [the portrait hall] is seven or eight *tan* [1 *tan* = 6 *ken*] away from the *kondō*." Therefore, according to this early twelfth-century author, the original portrait hall stood some eighty meters northwest of the *kondō*, which corresponds to the northern boundary of the western monks' quarters. The *Konryū engi* (History of the Establishment [of Tōshōdai-ji]) indicates that Ganjin's quarters had

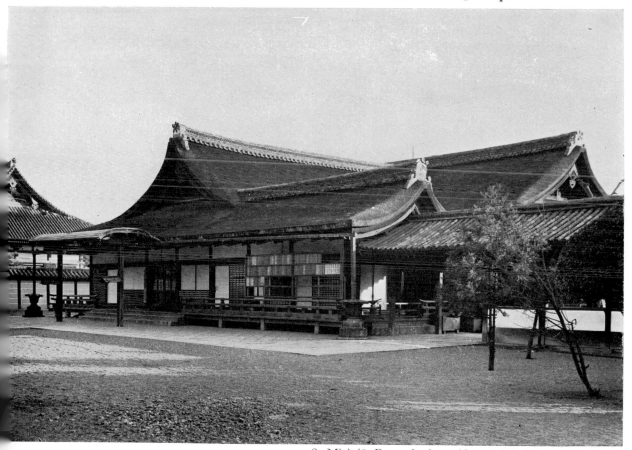

2. Miei-dō. Formerly the residence of Kūkai. Tō-ji, Kyoto.

been located in the northwestern monks' quarters, so that his residence and the later portrait hall were located on practically the same site.

The original portrait hall was not completed, however, until some time in the Heian period, and the dry-lacquer portrait must have been housed in another structure until that time. According to the *Tōsei den,* a biography of Ganjin written by his disciples, Ganjin made the following request of his disciple Shitaku: "When I die, build a separate portrait hall, and give my residence to the other monks to use as living quarters." From this quotation, one may surmise that a portrait had already been made and placed within Ganjin's residence. For some reason, however, a separate portrait hall was not constructed immediately following the abbot's death, and in the time intervening before the completion of the hall, the portrait most likely remained in the northwestern monks' quarters. When work on the portrait hall finally commenced, the chosen site was predictably that of his old residence.

The Heian-period portrait hall burned down in 1833, but the statue of Ganjin was rescued and temporarily installed in the *kōdō* (lecture hall). In 1884 a new portrait hall was created out of the *otamaya* ("residence of the spirit" [of members of the ruling Tokugawa family]), which had been transferred from the Tōshō-gū in Nikkō to Tōshōdai-ji at the request of the shogun Tokugawa Tsunayoshi during the Genroku era (1688–1704). This portrait hall was used until 1964, when a structure from the Ichijō-ji was transferred to Tōdai-ji, and it is here that the portrait of Ganjin is now enshrined.

The devotional aspect of portrait halls becomes apparent in the instance of the Kōzan-ji, a Kyoto monastery revived as a seminary for the Kegon sect by Myōe Shōnin (1173–1232) in the beginning of the Kamakura period. In the official records of the monastery, the *Kōzan-ji engi* (History of Kōzan-ji), are accounts relating to Myōe. Within the Zendō-in, the residential quarters, was the *jibutsudō* or personal devotional chapel of the monk. In this chapel were a rope mat used by Myōe during meditation and a painting of the master in contemplation by his former disciple Jōnin. This portrait was hung on the left side of the Zendō-in during the subject's lifetime and retained there after his death. Jōnin also painted the posthumous portrait of Myōe hung in the *gakumonjo* (study chamber) at the south end of the Zendō-in. On a desk in front of the latter portrait were placed a sutra, incense burners, and bells. A footrest, writing box, fan, conch, stove, and water jar were arranged nearby as they had been during Myōe's lifetime. It is said that the water in the jar at the time of his death was left untouched until 1253, twenty-one years later. Two or three attendants continued to serve his usual food and light the lamps, as if he were still alive.

The instances cited above indicate that portraits of monks were installed within halls converted from the former residences of the subjects. There were statues created and installed while the subject was still living, and also works created and enshrined by the disciples after the death of the master. There appears not to have been any real disparity between *juzō* (live portraits) and posthumous portraits; both types were

22

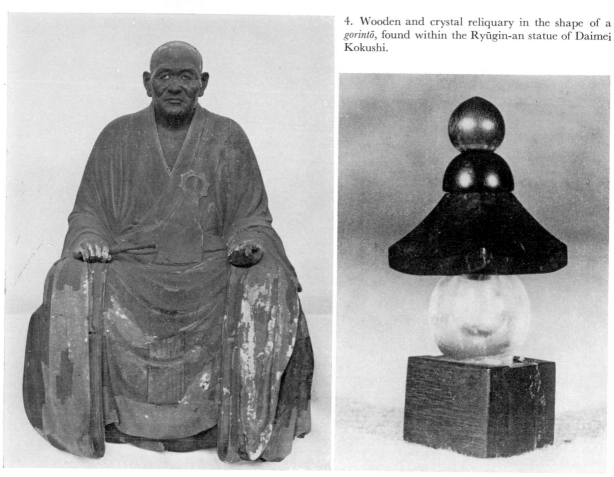

4. Wooden and crystal reliquary in the shape of a *gorintō*, found within the Ryūgin-an statue of Daimei Kokushi.

produced for the purpose of commemoration. The first portrait halls were originally commemorative in function, but from these relatively simple beginnings, the residential portrait halls developed into separate structures, became the centers of cult worship, and were transformed into elaborate structures.

Related Practices

The portrait halls heretofore discussed are structures specifically designated for that purpose, where the portraits of monks serve as the principal objects of worship. It should not be assumed, however, that all halls housing portraits have similar backgrounds and functions. For example, it is not unusual for portraits to be installed alongside other Buddhist images in the *hondō* (main hall), or in other halls for that matter. This practice occurs more often than not for reasons of convenience, and is far from being uncommon.

Portrait halls are also known to have been established at the place of burial of the subject. At Daigo-ji in Kyoto, the hall of the monk Shōbō, founder of the temple, has been thought to be such a structure. Further examples can be found among temples of the Zen sect: a wooden portrait of the monk Mukan Fumon, later known as Daimei Kokushi (pl. 3), who died in 1291, is enshrined in a cemetery of the Ryūgin-an at Tōfuku-ji. Interestingly enough, the Ryūgin-an was also the residence of the monk.

5–6. Ganjin (Chien-chen). Dry lacquer. H. 80.5 cm. Late Tempyō. Tōshōdai-ji, Nara.

A Chinese Buddhist monk of the T'ang dynasty, Ganjin resolved to come to Japan and suffered shipwreck and other hardships en route, including the loss of his eyesight. This portrait is said to have been made when one of Ganjin's disciples divined that his master was near death. If credence is to be given to this account, the portrait would date from 763, the year of his death. In any event, the work belongs to the late Tempyō era and shares the interest in realism common in Chinese as well as Japanese sculpture of that period. A great deal of care has been taken in the hollow dry-lacquer technique of this work, and the freshness and vigor of the naturalistic treatment of the figure made the Ganjin statue one of the outstanding works of early Japanese portraiture.

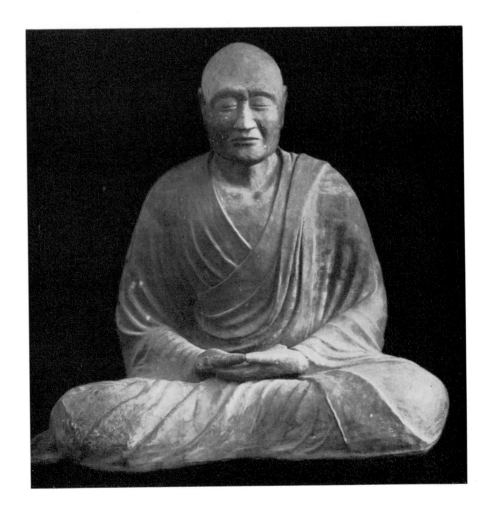

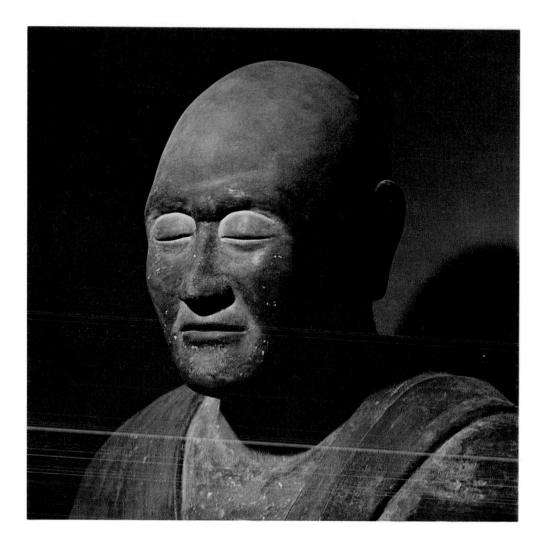

The erection of a portrait hall at the place of burial of the subject may have been motivated by a wish to create a physical correspondence between the remains of the monk and his portrait. Although the attitude behind this practice differs slightly from that actuating the transformation of residences into portrait halls, in both cases the portrait is used as a substitute for the living person and was created to recapture his physical presence.

Objects Deposited within Portrait Statues

Portraits are sculpted of wood, of dry lacquer, and, very rarely, of clay. The majority of works are executed in wood according to one of the two techniques common to Japanese sculpture in general: the single-woodblock *(ichiboku)* or assembled-wood-block *(yosegi)* methods. Sculptures produced by either technique may contain objects deposited within: statues carved in the *ichiboku* method would have a section hollowed out whose opening at the back of the image would be covered by a board; works made according to the *yosegi* technique would have an entirely hollow interior in which articles could be deposited. This practice was not limited to portrait sculpture, but was common to Buddhist sculpture as a whole.

Many different kinds of objects have been found deposited in portraits. A sampling of these includes dedicatory prayer texts, lists of names of those linked in devotion for specific endeavors, sutras, mantras, printed Buddhist images, miniature pagodas, symbolic relics of the Buddha and saints *(shari)*, symbols of the purity of the moon *(gachirin)*, small Buddhist statues, replicas of internal organs, and actual remains of the deceased subject of the portrait or of related persons. These objects would have been placed within sculptures for specific reasons, and an understanding of the significance of these materials serves to elucidate another of the characteristic aspects of Japanese portrait sculpture.

In general, the deposited objects are of either a commemorative or a devotional nature: the one strengthening the link between the deceased subject and his portrait, the other representing acts of piety on the part of those wishing to gain spiritual merit through such acts.

Deposits of Remains

A distinctive kind of deposited object in portrait sculpture is the remains of the deceased. In Buddhism (which offers great devotion to the relics of the Buddha and of saints), the supposed bodily remains of the historical Buddha, Śākyamuni, have often been placed within images of the Buddha, and this practice may well have influenced portrait sculpture. In addition, including a person's remains within his portrait imbued that image with his spirit, while worshiping a statue in which a person's ashes had been deposited served also as a memorial service to the deceased.

The portrait sculpture of Hottō Kokushi, who is also known as Kakushin (1207–

98), in the Kōkoku-ji in Wakayama Prefecture is one of the first Japanese representations of a Zen master *(chinsō)*. Within this figure were found a number of bronze tubes containing sutras and the names of devotees, one inscribed with the date 1286; a gilt-bronze pagoda-shaped reliquary; and bronze containers made for the express purpose of depositing remains.

The ashes of the famous monk Nichiren, placed in a bronze container (pl. 11), were discovered in his portrait in the Hommon-ji in Tokyo (pl. 10), made in 1288 on the sixth anniversary of his death.

In a portrait statue of the Shin-sect monk Ryōgen (d. 1336) in the Bukkō-ji in Kyoto was found a considerable amount of remains wrapped in paper on which was written the date 1344. In addition, there had been placed within the statue a fragment of a surplice, which must have belonged to Ryōgen, and a small wooden portrait head of the monk. Although the commemorative nature of the surplice is clear, the wooden head is unusual and of interest. It can perhaps be thought that the smaller head fulfills the same function as the remains in that both serve as instruments for the transference of the fundamental spirit of the deceased into the image, thus strengthening its identification with Ryōgen.

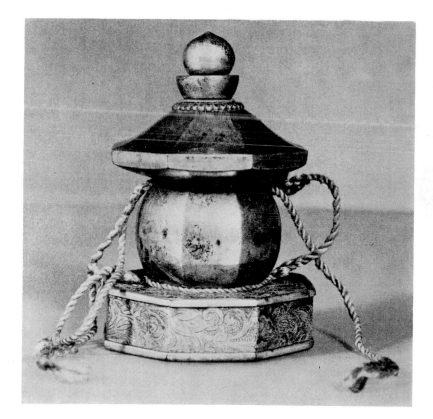

7. Octagonal gilt bronze *gorintō* found within the statue of Eizon (pls. 8, 82) in the Saidai-ji, Nara.

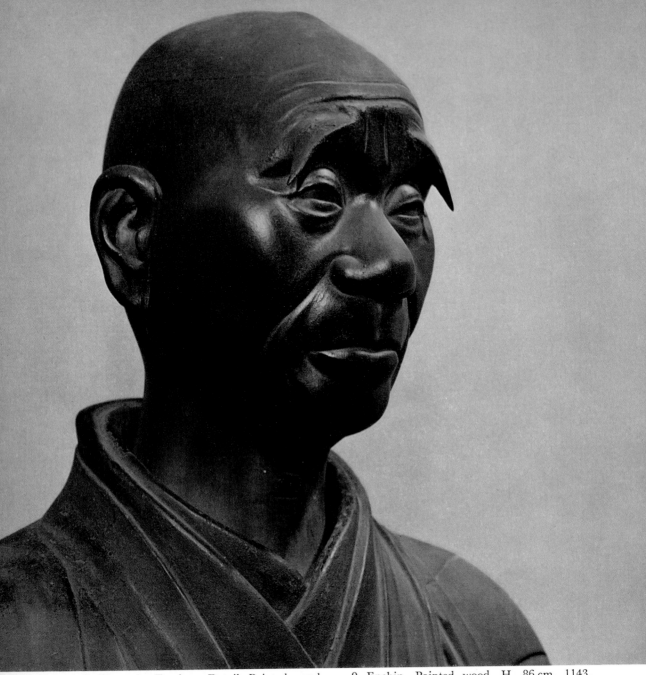

8. Eizon, by Zenshun. Detail. Painted wood. H. 89.3 cm. 1280. Saidai-ji, Nara.

This portrait of Eizon, the monk responsible for the Kamakura-period revival of the Ritsu sect, was carved by Zenshun in 1280 when the subject was seventy-nine years of age. Although the statue was produced with a realistic intent, the sculptor nonetheless appears to have delighted in the forms themselves, a tendency manifested in his exploitation of the expressive qualities of features such as the eyebrows. (For full view see pl. 82.)

9. Enchin. Painted wood. H. 86 cm. 1143. Shōgo-in, Kyoto.

This figure of Enchin, the founder of Onjō-ji and the Jimon subsect of Tendai esoteric Buddhism, was carved by the Buddhist sculptor Ryōkai after an older portrait, the so-called Sannō-in Daishi in the Onjō-ji (pl. 75). The shape of the head and the features are generally like those of the Sannō-in Daishi. The figure as a whole, however, is not quite as squat, and the drapery has been given a softer, more flowing treatment.

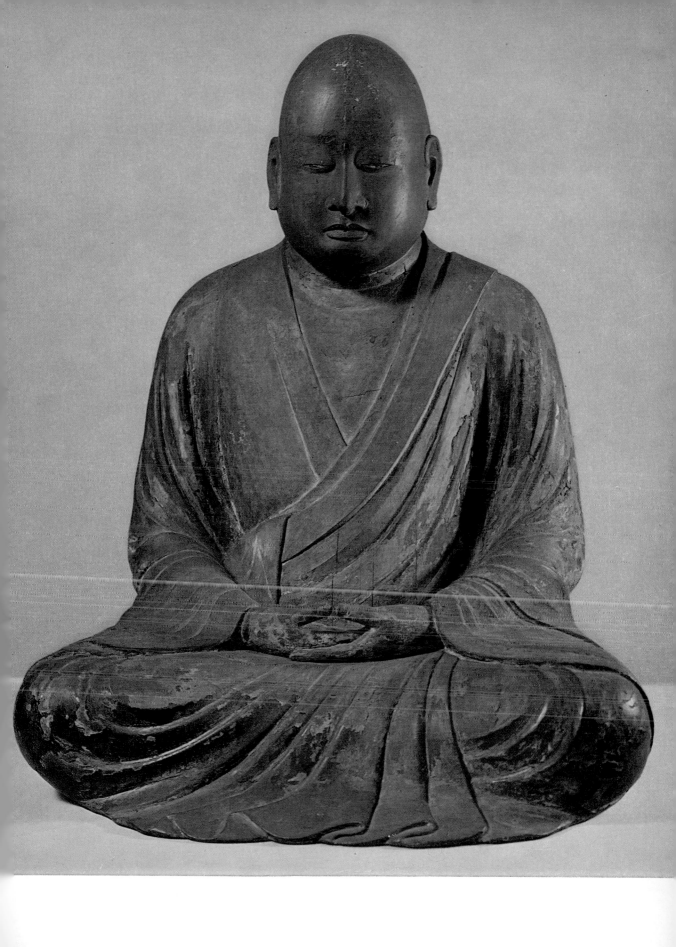

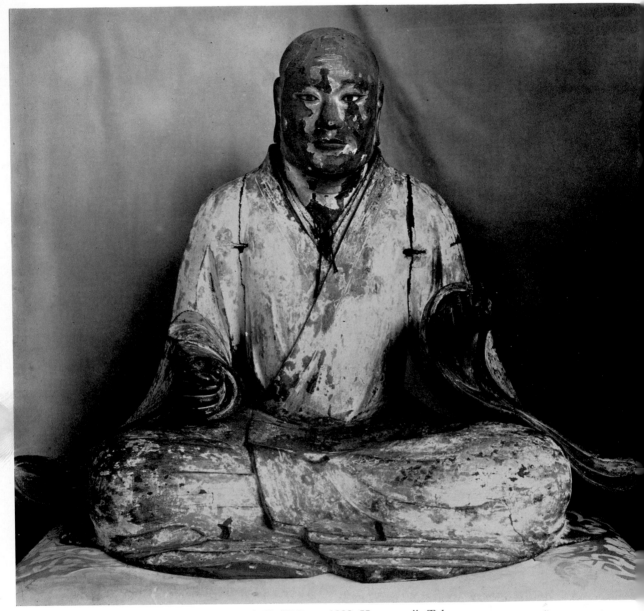

10. Nichiren. In undergarments. Painted wood. H. 85.7 cm. 1288. Hommon-ji, Tokyo.

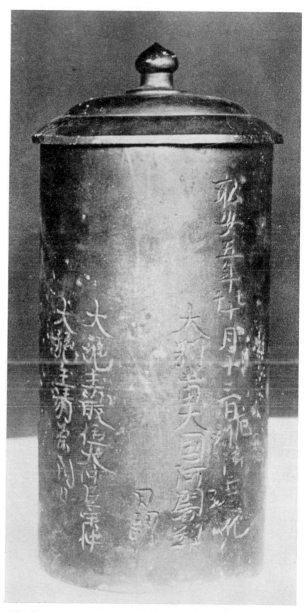

11. Bronze container in which the ashes of Nichiren are deposited. Found within the statue of Nichiren (pl. 10) in the Hommon-ji, Tokyo.

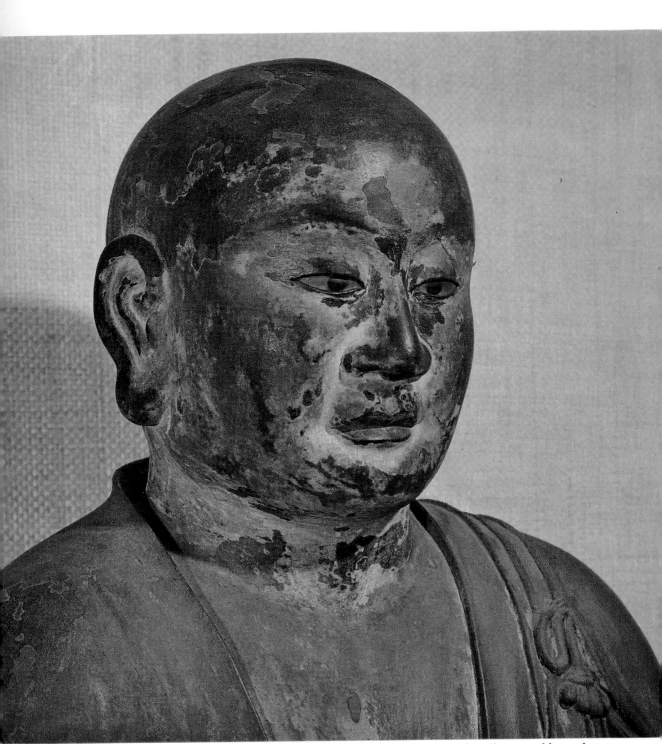

12. Kūkai. Detail. Painted wood. H. 82.1 cm. 1325. Gokuraku-bō, Gangō-ji, Nara.
This late Kamakura-period statue of Kūkai, founder of the Shingon sect, was modeled after the portrait in the Miei-dō of Tō-ji (pl. 70). Almost a century separates the two works, and it is apparent that the resemblance between them is superficial. Though this figure is indicative of the increasing stylization and crystalization of forms that occurred in the course of the later Kamakura period, it is nonetheless a noteworthy work. (See pl. 20 for full view.)

It was common practice to insert the ashes of the deceased within his own portrait, but in certain cases remains of persons other than the subject were placed within a statue. For example, ashes were found deposited in the head of an image of Shōtoku Taishi, in the Bukkō-ji in Kyoto, made by the Buddhist sculptor Tankō in 1320. They were identified as those of the monk Ryōkai by an inscription on the paper in which they were wrapped. The statue had been commissioned by the previously mentioned Ryōgen, who was the son of Ryōkai. Since Ryōkai had been a devout follower of Shōtoku Taishi, it is likely that after his death his son placed his ashes within the statue of Shōtoku Taishi to demonstrate the extent of his father's devotion.

Commemorative Objects

Other than the remains of the deceased, the objects most commonly placed within portraits with a commemorative function are articles used by the subject during his lifetime, or objects of great significance with regard to his achievements.

The realistic portrait of Daimei Kokushi (pl. 3) in the Ryūgin-an of Tōfuku-ji in Kyoto, made shortly after his death in 1291, contains deposited objects. Among recently discovered objects were a wooden, painted *gorintō*-shaped pagoda made by the monk (pl. 4); a fragment of a sutra written in his own hand; Sanskrit characters; a rosewood reliquary in the shape of a *gorintō* which had belonged to him; a glass jar once containing *shari* wrapped in brocade; a small rosary; and small sutra scrolls. These objects recalled the life of the monk and served to invest the portrait with his spirit.

It would be interesting to list, at least once, the entire contents of a portrait in order to appreciate the motivations involved in the practice of depositing objects within portrait statues. The Kamakura-period sculpture of the monk Eizon in the Saidai-ji in Nara (pls. 8, 82) was carved by the sculptor Zenshun in 1280 during the subject's lifetime. Packed tightly within this statue were texts and many other objects, including one octagonal gilt bronze *gorintō* (pl. 7); one sheet documenting *shari*; a scroll depicting the Taizōkai and Kongōkai mandalas of esoteric Buddhism in which deities are represented by Sanskrit "seed syllables"; one book of the *Bommō-kyō* (held to be the basic canon concerning the commandments of the bodhisattva in Mahāyāna Buddhism); one scroll of the *Daibutsu-chō darani* (the *dhāraṇī* or magic prayer formula that explains the virtues of the secrets of the Daibutsu-chō Nyorai); one scroll relating to the five kinds of untranslatable words in esoteric Buddhism; ten scrolls including the *Hoke-kyō (Lotus Sutra*, the chief sutra of the Tendai sect) and its introductory and closing texts; two scrolls of the *Hannya-haramitta-shin-gyō (Heart Sutra*, the essence of Prajñāpāramitā, or Perfection of Wisdom, literature stated in one page); the *Kankai gammon* (votive writings by the priest Kankai); one scroll of the *Hannya-rishu-kyō* (the sutra depicting the truth of the perfection of wisdom as spoken by Vairocana for the benefit of Vajrasattva); scrolls six and seven of the *Hike-kyō;* ten scrolls of the *Konkōmyō saishōō-kyō* (the sutra describing the various Buddhist demigods, espe-

cially divine kings who protect the Buddhist ruler who governs his country in a proper fashion); one scroll of the *Shibun-kaihon* (extracts from the four-division *vinaya* or rules of monastic discipline); six volumes of the *Bonji-kyō* (sutra on Sanskrit characters); one scroll listing dates when memorial services had been performed; a record of ordination; one scroll recording past benefactions to the Saidai-ji; three scrolls listing names of disciples who had received the bodhisattvic commandments; one package of Eizon's parents' bodily relics enclosed with three dedicatory prayer texts; fifteen copies of dedicatory prayer texts; one scroll of the *Kansei kigammon* (votive writings by the priest Kansei); one copy of the *Dōshin kishōmon* (votive writings expressing wishes to make the statue of the master); votive writings by both priests and nuns; and other documents added at a later date.

Many of these objects are related to the career and activities of Eizon. The record of his ordination was a vital document in his career as a monk of the Ritsu sect. Also, there could hardly have been anything more precious to the subject than the remains of his parents. Eizon's disciples had added such items as sutras transcribed or owned by the master, mantras and prayers, scrolls recording the names of people for whom he had performed the ordination ceremony, and lists of names of those who had donated toward the construction of the *saisōbō,* where the portrait of Eizon was installed. The many persons involved in the deposition of these articles within the portrait sculpture acted out of reverence for the monk and also out of a wish to secure merit through their actions.

The statue of Shōtoku Taishi enshrined in the Shōryō-in of Hōryu-ji in Nara (pl. 13), dedicated in 1121, contained similar material, although none of the objects can be said to have belonged to the prince. The items included a bronze statue of Kannon (the Bodhisattva Avalokiteśvara, pl. 14) and the three sutras most revered by Prince Shōtoku, the *Hoke-kyō,* the *Shōman-kyō,* and the *Yuima-kyō (Vimalakīrti-nirdeśa-sūtra,* which recounts the extremely popular story of Vimalakīrti, a lay follower of Buddha). The bronze, made in the style associated with the period in which Shōtoku Taishi lived, Asuka (538–644), was probably tied to the prince in the minds of the twelfth-century devotees by some now forgotten legend.

An example somewhat different from the foregoing is the wooden statue of the emperor Goshirakawa (r. 1155–58) in the Hokke-dō of the imperial tomb of Hōjū-ji in front of the Sanjūsangen-dō in Kyoto (pls. 18–19). A work of the mid-Kamakura period, it is executed in the realistic style prevalent at that time. Within the image was found a line drawing of the emperor (pls. 16–17), inscribed with a date (sixth month, thirteenth day of 1311) and the name of the artist (Tamenobu). Tamenobu was a celebrated portrait painter of the Kamakura period and descended from a family of renowned *nise-e* painters. The drawing was placed within the statue sometime after its construction. At that time, it may have been thought that painting captured the essence of a person more effectively than sculpture, so that the drawing was deposited in the statue in order to imbue it further with the subject's spirit.

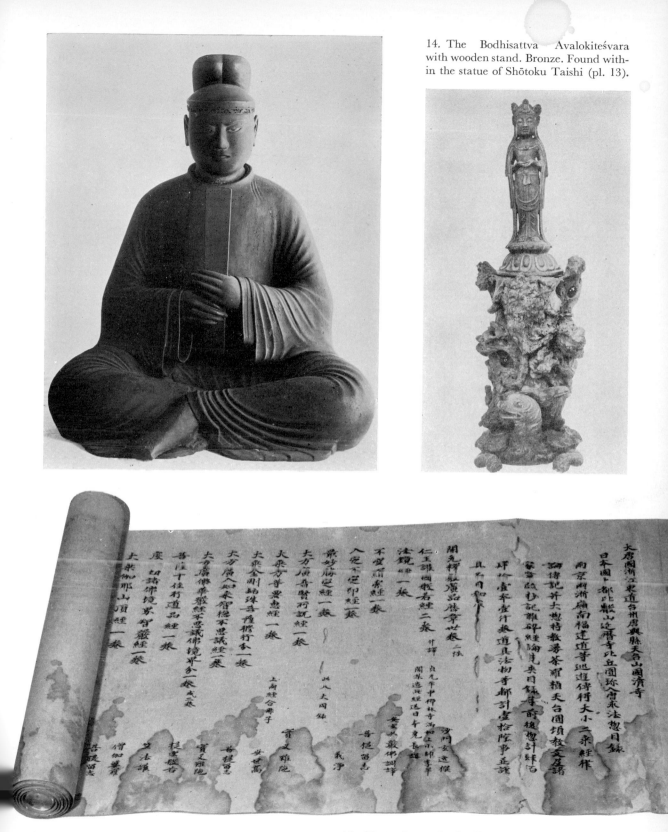

14. The Bodhisattva Avalokiteśvara with wooden stand. Bronze. Found within the statue of Shōtoku Taishi (pl. 13).

15. *Nittō guhō sōmokuroku* (Inventory of Buddhist Treatises Compiled while Visiting China). Found within the Shōgo-in portrait of Enchin (pl. 9).

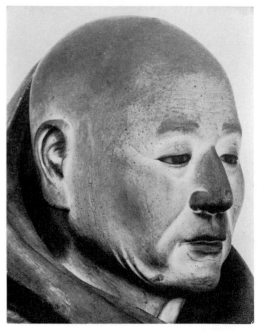

16–17 (above and below). Drawing of Emperor Goshirakawa, by Tamenobu. Found within statue of Goshirakawa (pls. 18–19).

18–19 (above and opposite). Emperor Goshirakawa. Painted wood. H. 89 cm. Kamakura period. Imperial Household Collection.

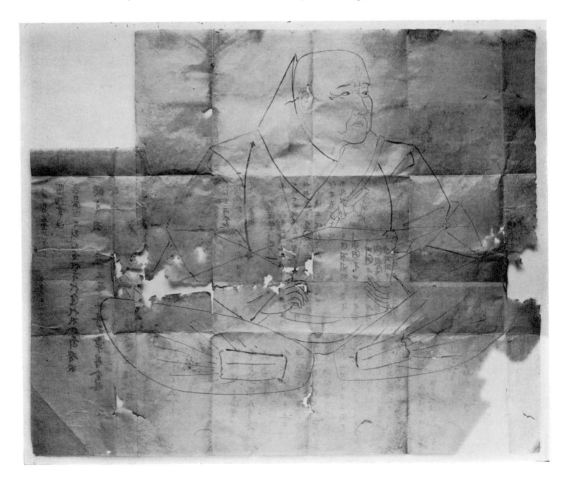

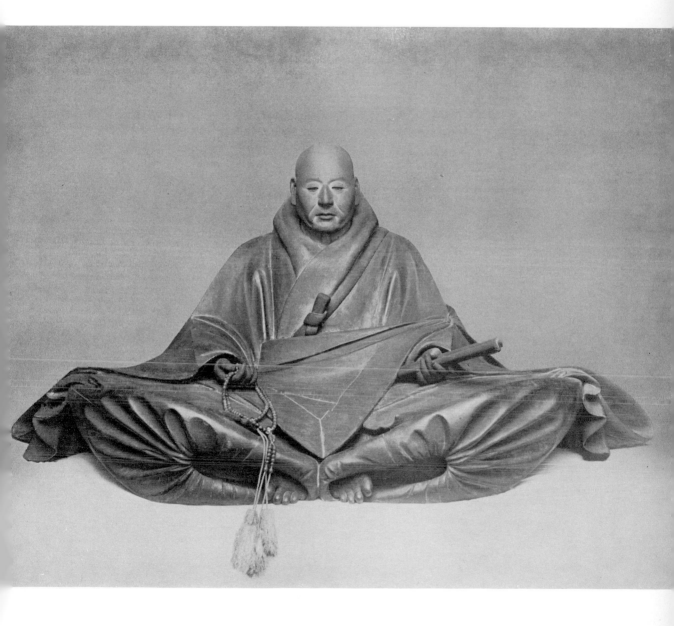

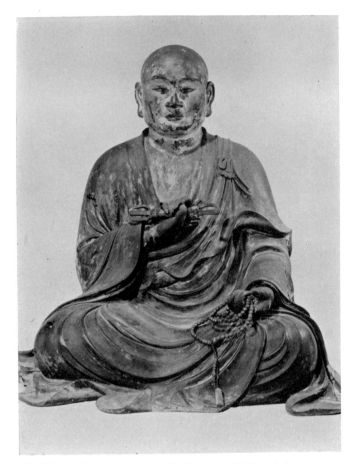

20. Kūkai. Painted wood. H. 82.1 cm. 1325.
Gokuraku-bō, Gangō-ji, Nara. (For detail see
pl. 12.)

Devotional Objects

The items falling into this category are generally articles not directly related to the subject of the portrait in which they were deposited. Rather, they reflect religious practices identical to those applied to Buddhist images of worship. The principal objects in this category include records relating to the construction of the statue, dedicatory prayer texts, lists of names of persons who formed a special devotional group, sutras, mantras, records of the performances of memorial services, printed Buddha images, *shari,* and *gorintō.*

The objects found deposited within the wooden portrait statue of Kūkai (pls. 12, 20) in the Gokuraku-bō of Gangō-ji in Nara included one sheet of votive writings by the priest Shuzen (pl. 24); five *shari* particles; forty-two sheets of stamped images of Aizen Myōō (Rāga-rāja, pl. 21); one scroll of the *Kannon-kyō* (the twenty-fifth chapter of the *Lotus Sutra,* relating to Avalokiteśvara); eight scrolls of the *Lotus Sutra ;*

21. One of the forty-two sheets of stamped images of Aizen Myōō. Found within the Gangō-ji portrait of Kūkai.

22. Amida-kyō. Inscribed 1325. Found within the Gangō-ji portrait of Kūkai.

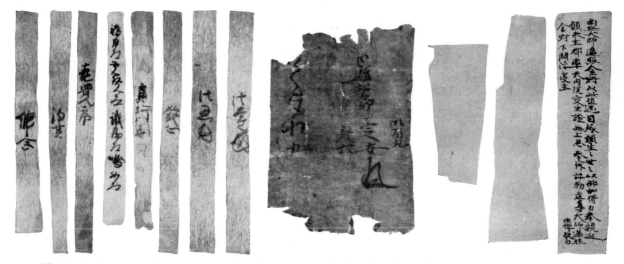

23. Twisted paper strings. Among the devotional objects found within the Gangō-ji portrait of Kūkai.

24. Votive writings by Priest Shuzen and other documents. Found within the Gangō-ji portrait of Kūkai.

one scroll of the *Muryōgi-kyō* (a one-fascicle sutra regarded as the introduction of the *Lotus Sutra*); one scroll of the *Kan Fugen-kyō* (a one-fascicle sutra on the subject of meditation on the Bodhisattva Samantabhadra, regarded as the epilogue to the *Lotus Sutra*); one scroll of the *Hannya-haramitta-shin-gyō* and the *Amida-kyō* (pl 22; one of the three sutras of Pure Land teaching, in which the Buddha speaks of his own volition and describes Amitābha and the Pure Land), the latter sutra, as well as three others, bearing the date 1325 in its postscript; one sheet of names of devotees dated 1345; one sheet of amulets; and twenty-nine twisted paper strings (pl. 23). The purpose of these deposited articles was to aid in the rebirth of Kūkai in the Tuṣita heaven *(tosotsu-ten)* of Maitreya and to pray for equal grace for all sentient beings, but they had no real relationship to the character or achievements of the monk. This practice differs little from that of placing prayer scrolls in Buddha images.

Usual examples of cult objects placed within so-called portraits include a wooden

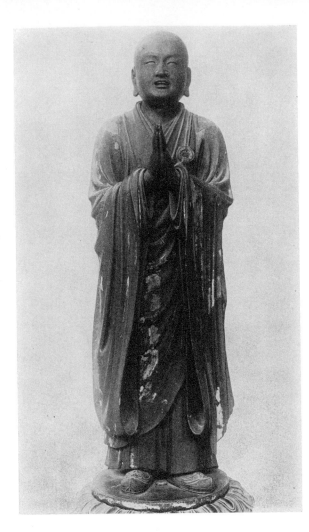

25. Shan-tao (Zendō). Painted wood. Kamakura period. Chion-in, Kyoto.

gachirin, or moon symbol, found within a statue of the young prince Siddhārtha (pl. 36) made in 1252 and enshrined in the Ninna-ji in Kyoto. The symbol in the shape of the moon's corona represents absolute purity. Placed within the chest of the statue, it functions as an analogy to the purity of the spirit of the young Siddhārtha, destined to forgo his princely life and become the historical Buddha, and serves as the spirit of the figure itself. Similar *gachirin* were placed within Buddhist statues in general, such as the well-known Heian-period Amitābha by Jōchō in the Byōdō-in in Uji, the Kamakura-period figure of Amitābha in the Dainen-ji in Kyoto, and the two statues of Kongara and Seitaka Dōji in the Kongōbu-ji on Mount Kōya.

It should also be noted that the Kamakura-period portrait of the founder of the Chinese Pure Land sect, Shan-tao (Zendō, pl. 25), in the Chion-in in Kyoto contained internal organs made of brocade (pls. 26–29). The practice of including artificial viscera can be seen in Chinese examples, such as the famous statue of Śākyamuni in the Seiryō-ji in Kyoto. The Śākyamuni is dated 985 and is a Northern Sung (960–1126) work brought to Japan by the monk Chōnen. The silk internal organs were meant to suggest the living presence of the historical Buddha. The placement of viscera within the portrait of Shan-tao is probably a manifestation of Chinese Buddhist influence.

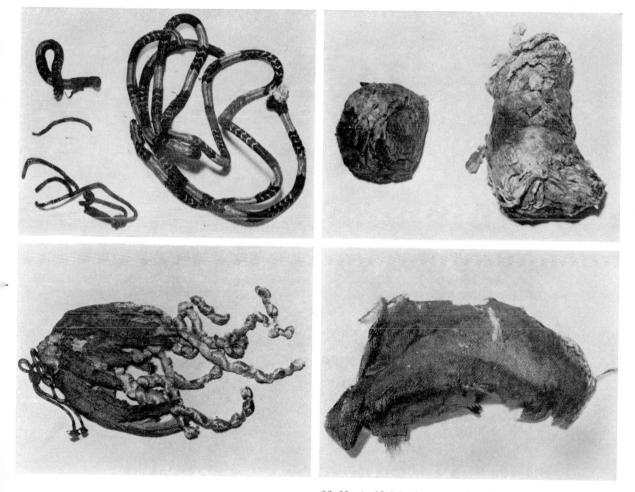

26–29. Artificial viscera made of brocade. Found within the statue of Shan-tao (pl. 25).

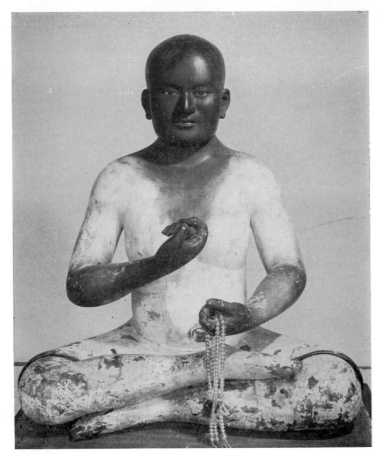

30. Kūkai. Unclothed. Painted wood. Shō-ren-ji, Kanagawa Prefecture.

Unclothed Portrait Sculptures

Unclothed statues are to be found not only among portraits but also among Buddhist images in general, especially representations of Amitābha (Amida Nyorai), Kṣitigarbha (Jizō), and Sarasvatī (Benzai-ten) of the Kamakura and succeeding periods. It is therefore necessary to consider the unclothed portraits in the larger context of realistic imagery. Unclothed representations appear in Shintō sculpture as early as the Heian period, such as in the statue of a Shintō deity traditionally called Takenouchi no Sukune in the Tō-ji in Kyoto, believed to be a work of the late Heian period. The possibility of a relationship between such Shintō statues and unclothed images in general from the Kamakura period onward should not be overlooked.

Unclothed portraits and unclothed Buddhist statues were produced with the intention of their being dressed in actual garments. Worshipers would offer daily devotions to the statue by dressing it in garments that they themselves had made, and, in doing so, deepen their sense of fellowship with the deity. The oldest example of an unclothed Buddhist image is the sculpture of Kṣitigarbha (Jizō) in the Denkō-ji in Nara made in 1228. Buddhist nuns are known to have commissioned the work, and they dressed

42

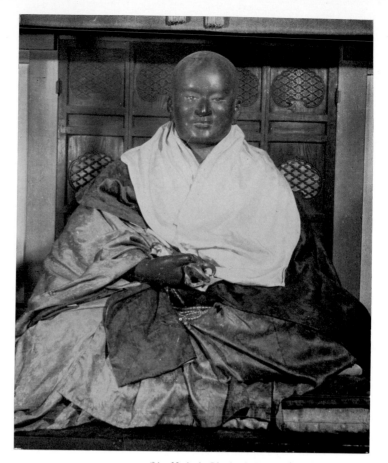

31. Kūkai. Clothed. Painted wood. Shōren-ji, Kanagawa Prefecture.

the figure in garments which they had sewn themselves. One should keep in mind the motivation of those who commissioned the unclothed portrait statues. In worshiping them, a devotee would be highly conscious of the service he was performing, as if the portrait were actually the living person, and the act of dressing the figure would be invested with great meaning.

An example of a completely unclothed figure is the portrait of Kūkai in the Shōren-ji in Kanagawa Prefecture (pls. 30–31). Kūkai is shown seated grasping a five-pronged *vajra* (thunderbolt) in his right hand and the rosary in his left. The statue has not only inlaid eyes but also quartz inlays for the fingernails, and both of the legs are provided with joints at the knees so that they can bend—these are examples of the hyperrealistic techniques used during the Kamakura period. The unclothed body was naturalistically rendered as well, but was not meant to be viewed in that state, for it was ordinarily enshrined clothed in an actual garment.

The statue of Nichiren Shōnin in the Hommon-ji in Tokyo (pl. 10) shows the monk represented in his undergarments, but when enshrined, it is dressed in an actual surplice. This method of representation reflects much the same spirit as that of unclothed sculptures.

32. Ikkyū Oshō. Detail. Painted wood. H. 83.3 cm. C. 1481. Shūon-an, Kyoto.

This Muromachi-period portrait of the famous Zen monk Ikkyū is highly unusual in that the actual hair of the deceased subject had originally been implanted in the head and the face of the statue. The hair was applied not only to represent external appearances but also to inject the spirit of Ikkyū directly into his portrait. Made immediately after the subject's death in 1481, the rough quality of the face contrasts with the smooth, broad, decorated drapery. (See also pl. 33.)

Implanted Hair

In this category the first statues that come to mind are representations of Shōtoku Taishi. Among the statues of Shōtoku Taishi at different ages and of various symbolic functions, actual human hair was implanted in a number of figures depicting the prince at age sixteen offering filial piety to his father. There are statues of this type in the Kakurin-ji in Hyōgo Prefecture, the Daishō Shōgun-ji in Osaka, and the Gongen-ji in Kyoto. Furthermore, it is interesting to note that all of these statues are rendered unclothed or in their undergarments and are enshrined wearing actual robes. Thus the devotional aspect of unclothed statues described above is also applicable to these figures of Shōtoku Taishi, and the use of implanted hair must have been appropriate to images made to be clothed in actual garments. Such images are characteristic of the distinctive popular cult of Shōtoku Taishi that flourished in the Kamakura period, while the donation of the hair itself was a solemn gift from the Buddhist devotees.

Of a slightly different character is the portrait of the celebrated Zen monk Ikkyū in the Shūon-an near Kyoto (pls. 32–33). This outstanding work of the Muromachi period admirably reflects the actual appearance of the monk, and the statue bears traces of implanted hair (most likely hair of Ikkyū himself) on the head, eyebrows, upper lip, and chin. In this case, actual hair had been applied not only to represent external appearances, but also to inject the spirit of Ikkyū directly into his portrait. The thought process involved in such a practice corresponds exactly to that involved when inserting the possessions or actual remains of the subject into hollow portrait statues.

33. Ikkyū Oshō. (See pl. 32 for detail.)

2

IMAGINARY PORTRAITS

Japanese portrait sculpture falls into two general categories: imaginary portraits and portraits of historical personages. These two groups, the characteristics of which are more often determined by religious factors than by artistic considerations, are not mutually exclusive, and it becomes at times difficult to draw clear distinctions between them. In cases where the representation of the subject is reasonably grounded in fact, and there is evidence to assume that the portrait is based on observation, however indirect, of the subject, the portrait has been termed "historical." In instances where the subject was so removed in time or place that he could not have been observed, and his portrait was purely conjectural, the depiction has been called "imaginary."

Portraiture in a religious context with strong commemorative and devotional significance often includes personages belonging to the legendary or distant historical past, whose portraits must necessarily be imaginary and reconstructed from textual sources and religious tradition. Artists of different periods in the history of Japanese sculpture have produced varying solutions to the problem of portraying quasi-historical personages, ranging from idealized representations identifiable only through conventional forms and attributes, to intensely realistic statues based on the sculptor's translation into visual terms of the professed character of the subject.

SIDDHĀRTHA

The historical Buddha, born the son of the king of Kapilavastu in northeastern India near Nepal, lived during the sixth and fifth centuries B.C. At the age of twenty-nine, the prince renounced his title and left his home and family to become a wandering ascetic. Until that time, he was called by the name Siddhārtha. Of all the personages treated in this chapter, Siddhārtha is the least likely to be considered a true portrait subject, for he is the most remote, in both spiritual and temporal terms.

The statue of Siddhārtha in the Ninna-ji in Kyoto (pl. 36) was carved in 1252 by the sculptor Inchi of the so-called In school. It was apparently strongly influenced by representations of Shōtoku Taishi as a youth and was in fact called "Shōtoku Taishi

34. Shan-tao (Zendō). Painted wood. Early Kamakura. Raigō-ji, Nara.

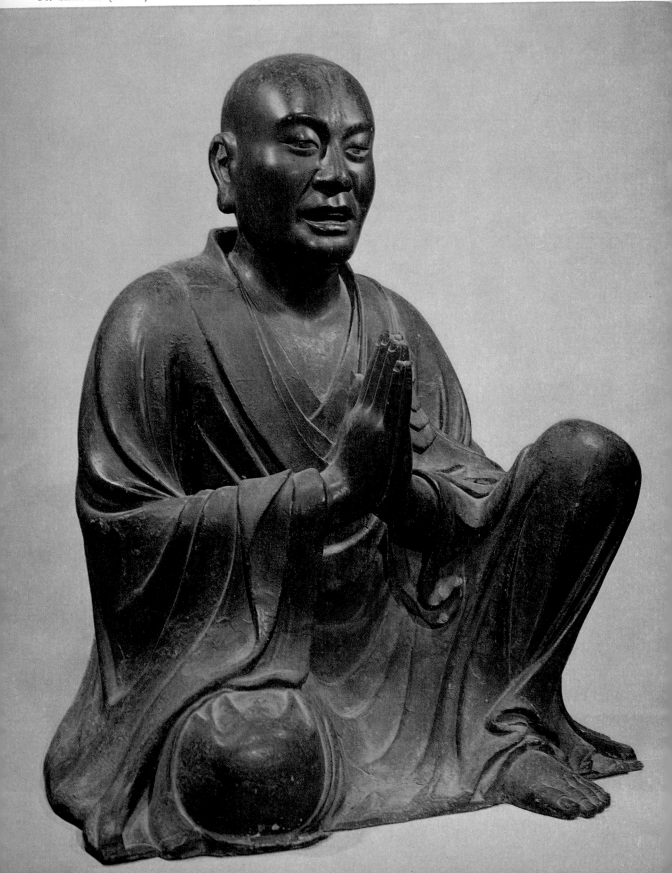

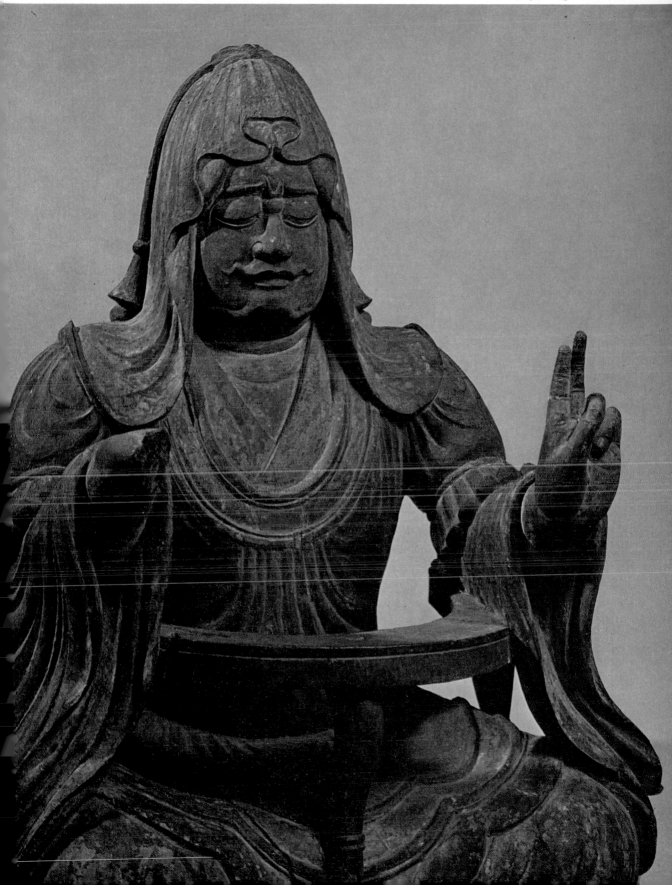

35. Vimalakīrti (Yuima). Detail. Painted wood. H. 34 cm. Late Heian. Seiryō-ji, Shiga Prefecture.

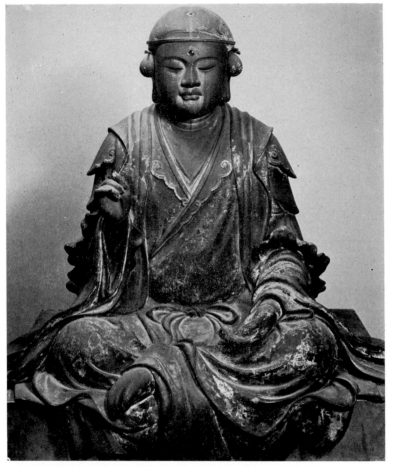

36. Siddhārtha (Shitta Taishi), by Inchi. Painted wood.
H. 71 cm. 1252. Ninna-ji, Kyoto.

in T'ang dress" earlier in this century, until the contents of the statue were revealed
and the figure was found to represent Siddhārtha. Carved when the great Kei-school
sculptors had already produced their definitive works that established the Kamakura
realistic style, and when influences from Sung China were being assimilated, the
Ninna-ji Siddhārtha exhibits elements derived from both of these sources. The Sung
manner is especially apparent in the type of garment and the treatment of the drapery.

THE TEN GREAT DISCIPLES

50 Depictions of the ten disciples of the historical Buddha developed in China and appear

in sculpture as early as the sixth century A.D. in the Ku-yang cave at Lung-men. Roughly two hundred years later, the group appears in Japan as a set of dry-lacquer statues in the Kōfuku-ji in Nara. Other well-known Japanese representations are the Kamakura-period works in the Kyoto temples of Seiryō-ji and Daihōon-ji, the latter carved by the master sculptor Kaikei, and the set in the Gokuraku-ji in Kanagawa Prefecture.

The Ten Great Disciples *(jūdaideshi)* are Śāriputra (Sharihotsu, pls. 43, 49), the most brilliant of the group, known for his wisdom; Maudgalyāyana (Mokkenren, pls. 38, 51), who is said to have been particularly skilled in the six supernatural powers acquired by a Buddha or an arhat; Mahākāśyapa (Daikashō, pl. 48), an early disciple well versed in ascetic practices; Aniruddha (Anaritsu, pl. 46), a cousin of the Buddha who lost his eyesight but acquired the miraculous eye enabling him to see intuitively; Subhūti (Subodai, pls. 39, 50), the best exponent of the concept of *śūnya,* the void, and thus the principal interlocutor in the *Prajñāpāramitā-sūtra;* Pūrṇa (Furuna, pls. 40, 52), noted as the most eloquent of the disciples; Kātyāyana (Kasen-nen, pls. 42, 47), who understood fundamental principles; Upāli (Ubari, pl. 37), the principal compiler of monastic regulations, whose title was "keeper of the laws"; Rāhula (Ragora, pls. 41, 45), Śākyamuni's only son, the master of esoteric practices; and Ānanda (Ananda, pl. 44), the favorite disciple of the Buddha, famed for his excellent memory.

Many of the figures of the Ten Great Disciples are represented clothed in Buddhist robes, wearing shoes or sandals. Few of the images have Indian features, for almost all have been Japanized and idealized as well. No specific conventions regulating their appearance seem to have been established, with the exception of Ānanda. Ānanda is always represented as young and handsome, for he is supposed to have been a very attractive young man with a "face like a full moon," "eyes like blue lotus flowers," and a "body like a clear mirror." Legends about him describe him as having features that stirred many women.

According to the *Shichidaiji junrei shiki,* an image of Mahākāśyapa wearing a monk's stole over his head had once existed among the statues of the Ten Great Disciples in Kōfuku-ji, of which six now remain. According to Buddhist legend, Śākyamuni had given a monk's stole to Mahākāśyapa, which he then personally delivered to the future Buddha Maitreya. The stole worn by the statue had probably been an allusion to this event. However, such representations of specific attributes do not occur in the figures of the other disciples, and appear not to have been generally employed.

The statues of the ten disciples in Kōfuku-ji date from the Nara period, while the Daihōon-ji statues are from the Kamakura period. The Kōfuku-ji figures reflect the Buddhist realism prevalent in the art of T'ang China and Nara-period Japan, while the Daihōon-ji works were carved by Kaikei, a sculptor trained in the Kei school. This school of sculpture was strongly influenced by the realistic works of the Nara period, but also assimilated many elements of Chinese sculpture of the Sung period. 51

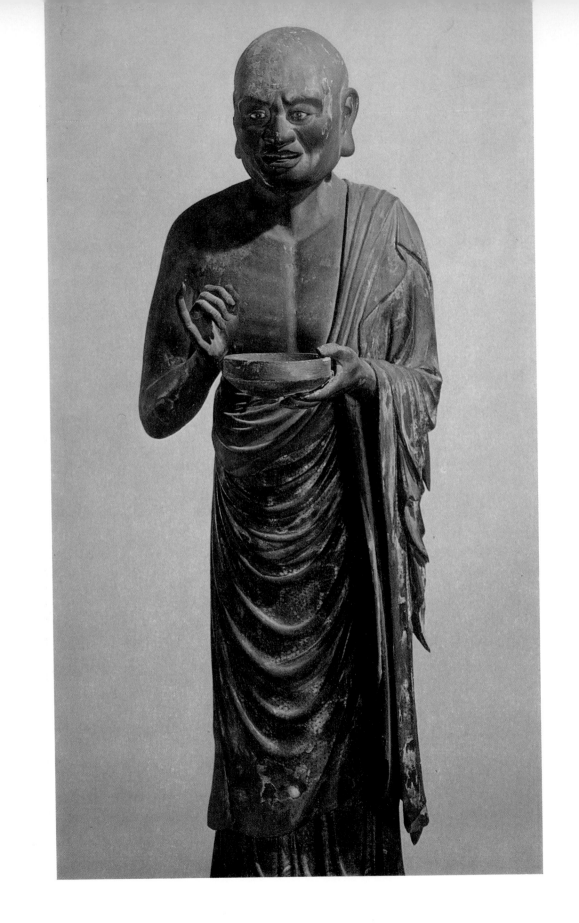

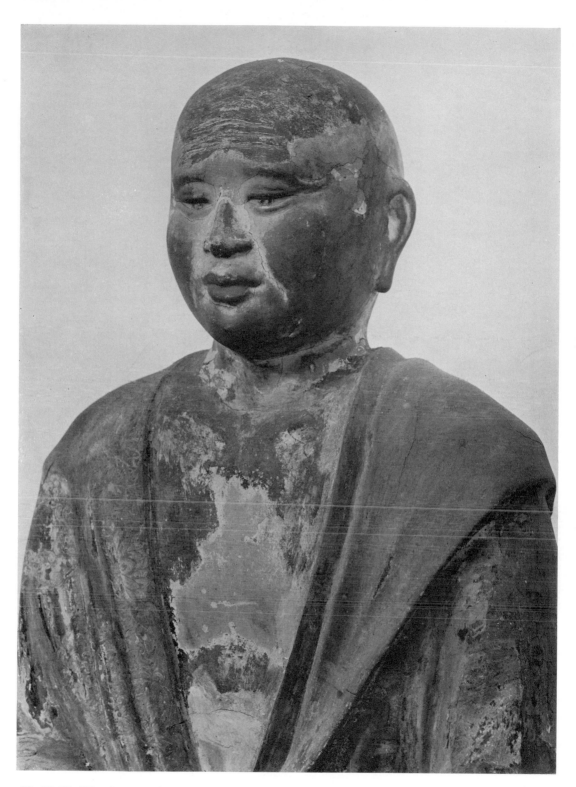

37. Upāli (Ubari), one of the Ten Great Disciples. By Kaikei. Detail.
Painted wood. H. 95.4 cm. Early Kamakura. Daihōon-ji, Kyoto.

38. Maudgalyāyana (Mokkenren), one of the Ten Great Disciples. Detail.
Dry lacquer. H. 148 cm. C. 734. Kōfuku-ji, Nara.

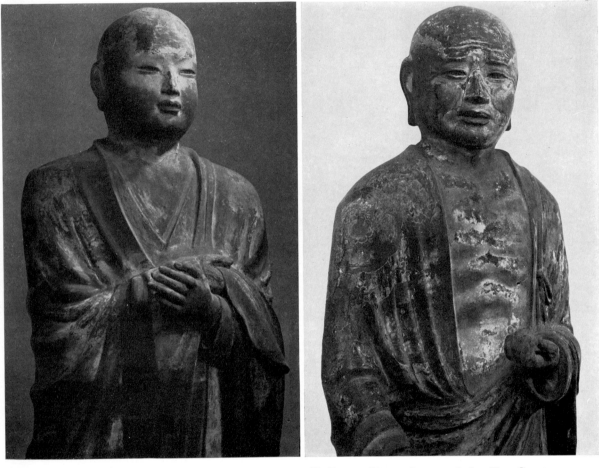

39. Subhūti (Subodai), one of the Ten
Great Disciples. Detail. Dry lacquer. H.
148.7 cm. C. 734. Kōfuku-ji, Nara.

40. Pūrṇa (Furuna), one of the Ten Great
Disciples. Detail. Dry lacquer. H. 148.7 cm.
C. 734. Kōfuku-ji, Nara.

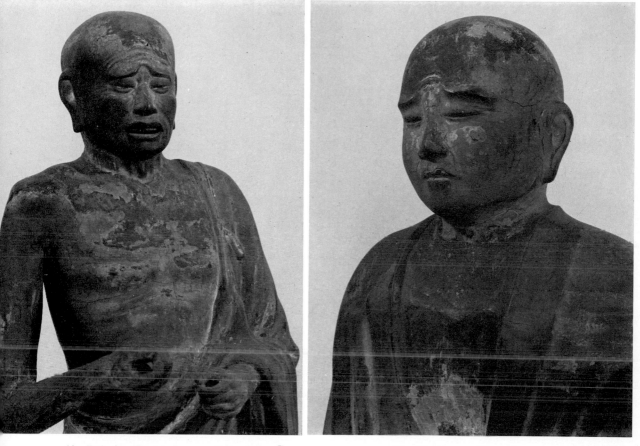

41. Rāhula (Ragora), one of the Ten Great
Disciples. Detail. Dry lacquer. H. 149,4 cm. C.
734. Kōfuku-ji, Nara.

42. Katyāyana (Kasennen), one of the Ten
Great Disciples. Detail. Dry lacquer. H.
144.3 cm. C. 734. Kōfuku-ji, Nara.

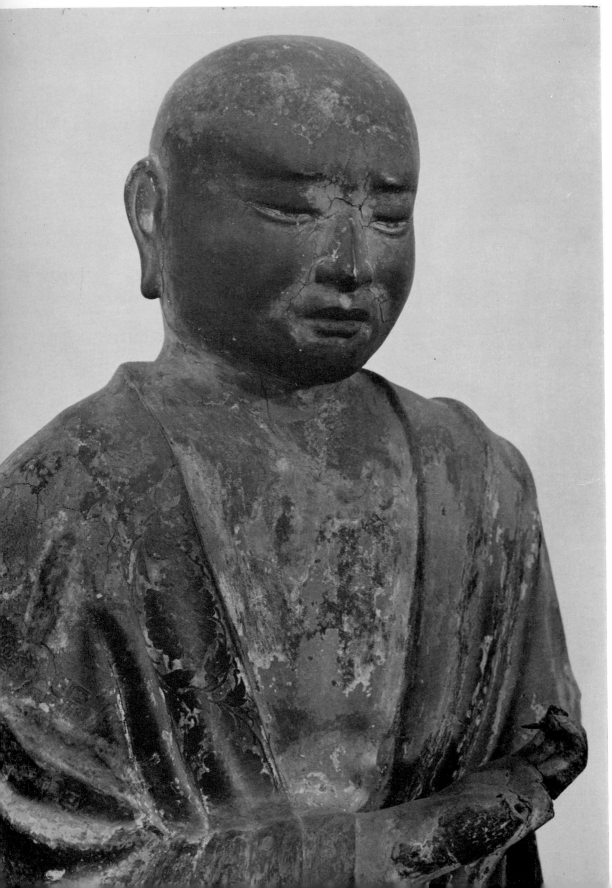

43. Sāriputra (Sharihotsu), one of the Ten Great Disciples. Detail. Dry lacquer. H. 152.7 cm. C. 734. Kōfuku-ji, Nara.

44. Ānanda (Ananda), one of the Ten Great Disciples. By Kaikei. Detail. Painted wood. H. 99 cm. Early Kamakura. Daihōon-ji, Kyoto.

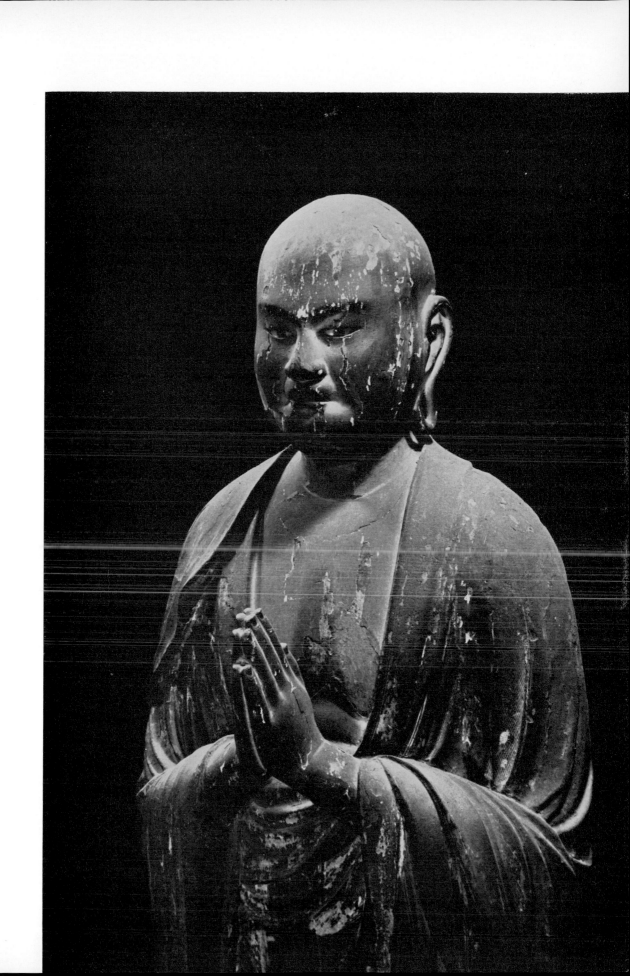

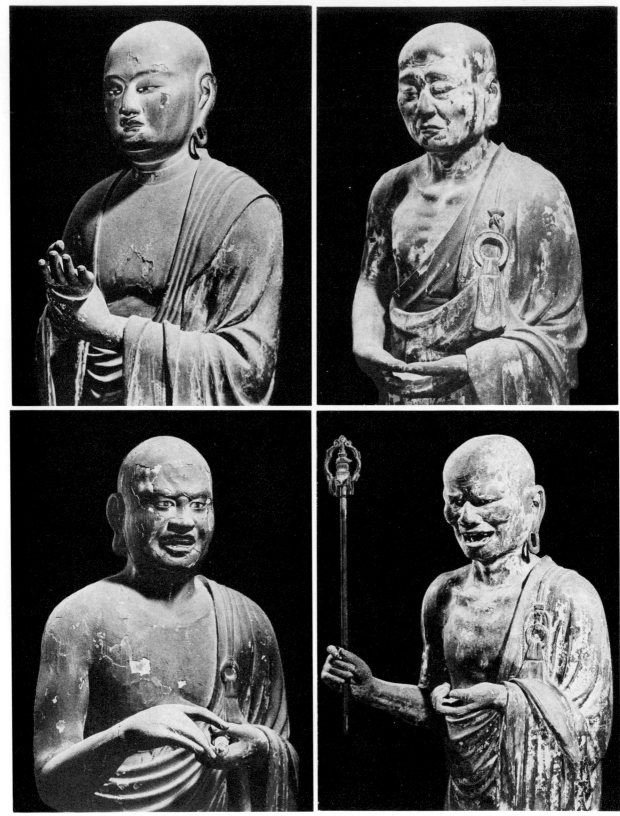

45. Rāhula (Ragora). H. 98.5 cm.
46. Aniruddha (Anaritsu). H. 99 cm.

47. Kātyāyana (Kasennen). H. 99 cm.
48. Mahākāśyapa (Daikashō). H. 99 cm.

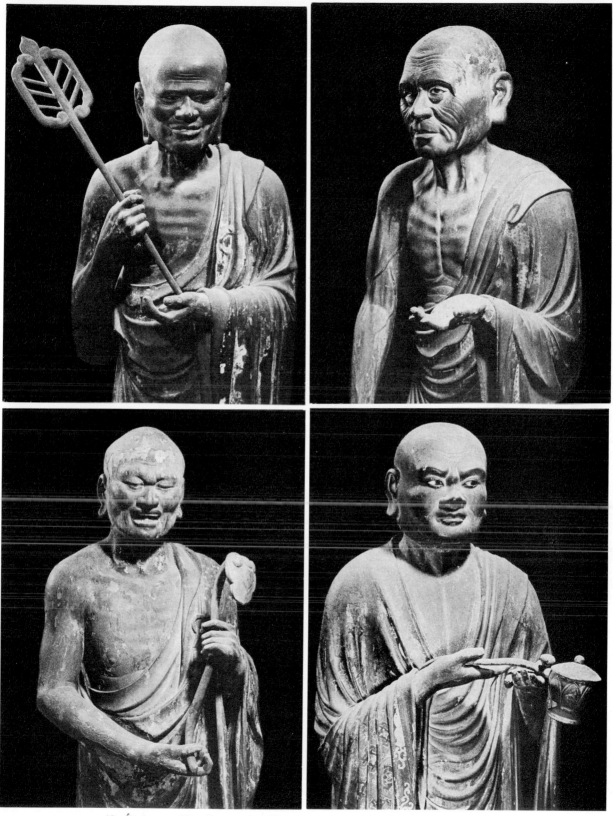

49. Śāriputra (Sharihotsu). H. 99 cm.
50. Subhūti (Subodai). H. 95 cm.

51. Maudgalyāyana (Mokkenren). H. 96.7 cm.
52. Pūrṇa (Furuna). H. 96.9 cm.

VIMALAKĪRTI

According to the *Vimalakīrti-nirdeśa-sūtra,* the influential Mahāyāna text composed sometime around the second century A.D., Vimalakīrti (Yuima) was a layman who lived in Vaiśālī in north central India during the lifetime of the historical Buddha. Vimalakīrti had devoted himself to Buddhism, and had managed to reach the height of spiritual attainment, but he remained a layman and did not engage in monastic austerities. Nonetheless, his insight and eloquence were such that, among all the bodhisattvas and disciples of the Buddha, only Mañjuśrī (Monju), the bodhisattva of wisdom, felt sufficiently confident to debate with him.

The concept of lay Buddhism expressed in the *Vimalakīrti-nirdeśa-sūtra* appealed greatly to the Chinese, whose traditions of governmental authority and social responsibility were not easily reconciled with the demands of Buddhist monasticism. The ideal of the lay Buddhist was transmitted from China to Japan, where its first great exponent was none other than Shōtoku Taishi, who composed a commentary on the Vimalakīrti sutra.

In China, the dramatic confrontation between Vimalakīrti and Mañjuśrī was a favorite subject for sculpture and painting during the Six Dynasties (222–589) and the T'ang periods. In Japan, elaborate representations of the confrontation between these two never became popular: the only early Japanese equivalent of these scenes is the group of dry-clay figures, dated 711, on the east side of the ground floor of the five-storied pagoda of the Hōryū-ji (pls. 53, 54). The small size of the figures precluded careful individuation of each of the participants, but the group as a whole is expressive and naturalistic.

The wooden figure of Vimalakīrti now in the Hokke-ji in Nara (pls. 55–56) conforms to the description given of the sage in the *Vimalakīrti-nirdeśa-sūtra:* Vimalakīrti feigned illness in order to dramatize his sermon on the infirmities of the human flesh. The Hokke-ji statue depicts an old man wearing the head cloth of an invalid, gesticulating as if in conversation. Dating to the early Heian period, this work, though not a portrait in the true sense, treats its subject in an unidealized manner closer to portraiture than to Buddhist cult images.

The late ninth-century figure of Vimalakīrti in the Ishiyama-dera in Shiga Prefecture (pl. 58) can hardly be termed a portrait. Rather, it is more allied to native craft traditions. Carved out of a single woodblock, its square, squat form does not reflect the dramatic or dynamic quality of the subject and betrays its distance from the mainstream of sculptural development.

The statue of the sage in the Seiryō-ji (pl. 35), a subtemple of Enryaku-ji on Mount Hiei, may date to the late ninth or early tenth century. Though sculpturally better conceived than the Ishiyama-dera figure, its stiff, frontal pose and schematization of forms impart a hieratic quality that makes it hardly more portraitlike than the previous work.

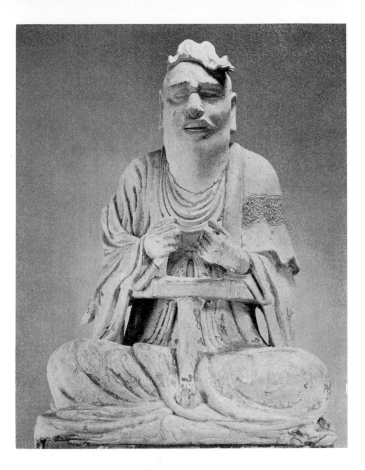

54. Group of dry-clay figures. 711. Five-storied Pagoda. Hōryū-ji, Nara.

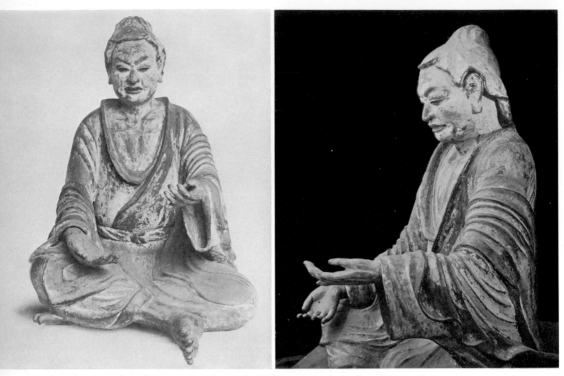

55–56. Vimalakīrti (Yuima). Painted wood. H. 92 cm. Early Heian. Hokke-ji, Nara.

57. Vimalakīrti (Yuima), by Jōkei. Painted wood. H. 88 cm. 1196. Kōfuku-ji, Nara.

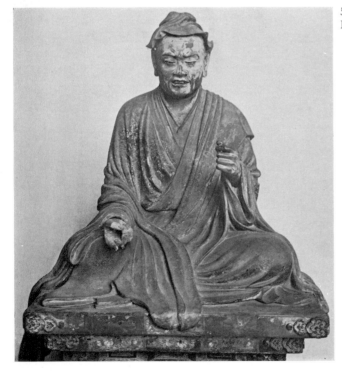

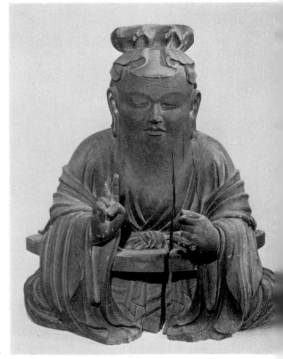

58. Vimalakīrti (Yuima). Single-woodblock construction. H. 51 cm. Late ninth century. Ishiyama-dera, Shiga Prefecture.

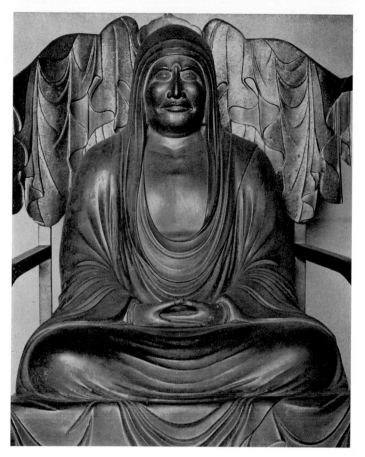

59. Bodhidharma (Daruma), by Shūkei. Carved out of an older statue, and painted by Shūbun. 1430. Daruma-dera, Nara.

All three of the above statues were made as independent images. In contrast, the Kamakura-period work carved by the sculptor Jōkei in 1196 (pl. 57), in Kōfuku-ji in Nara, was made to form part of a set with the Bodhisattva Mañjuśrī, although the figures are not closely interrelated. In this figure, the budding spirit of Kamakura realism can be seen; and it is hardly a coincidence that this figure most closely resembles the Hokke-ji work, for the sculptors of the Kamakura period were in part inspired by the experiments in naturalistic representation made by their Nara-period counterparts.

BODHIDHARMA

The third child of a southern Indian king, Bodhidharma (Daruma) studied the Buddhist doctrine, concentrating on the *dhyāna,* or meditative practices. Late in life he decided to do missionary work in the east, and embarked for southern China by sea, arriving in A.D. 520. He is reputed to have had an audience with the emperor Liang Wu-ti and proceeded to spread the teachings of the meditative school (Zen, or Ch'an in Chinese) throughout China. He settled in the city of Loyang in the Kao-shan Shao-lin monastery, where he spent the rest of his days facing a wall in silent medita-

tion. Emperor Kuang Ming sent him frequent offers of employment, but Bodhidharma did not respond. One of his disciples, Hui-k'o, is said to have cut off his arm in order to prove that he was worthy of receiving instruction from the sage. Bodhidharma is believed to have died in 528.

Bodhidharma is thus reputed to have been the founder of the meditative sect in China, and his images were often produced in the Sung and Yüan (1271–1368) periods in connection with the sect. There are various legends concerning Bodhidharma that appealed to the artistic imagination of the Chinese: his supposed crossing of the Yang-tse River standing on a single reed; his audience with Emperor Liang Wu-ti; his prolonged meditation in front of a wall; and Hui-k'o's self-sacrificing resolution to become a disciple of Bodhidharma. These subjects, however, appear almost exclusively in painting, while the single seated figure is more common in sculpture. He is then represented in a simple monastic robe with his head covered, his hands joined in meditation, and he is shown as a physically large man. There is a wooden image of Bodhidharma dating to the Kamakura period in the Empuku-ji in Kyoto, and in the Daruma-dera in Nara is a statue (pl. 59) carved by Shūkei in 1430. The latter was carved out of an older statue and painted by the celebrated monk-painter Shūbun.

PAO-CHIH

Pao-chih (Hōshi in Japanese), known also as Chih-kung, was a famous figure of early Chinese Buddhism, often mistakenly honored as the third Chinese patriarch of the religion. He was renowned as a holy man and magician and is said to have converted Emperor Liang Wu-ti into his most fervent disciple. After his death in 514, there developed legends crediting him with supernatural powers, and it came to be believed that he could transform himself into the likeness of a bodhisattva.

In the Saiō-ji in Kyoto is an unusual statue of Pao-chih (pl. 60), more cult image than portrait, representing the monk as he manifests his true form as the Bodhisattva Avalokiteśvara. The head of the monk is split vertically in two to reveal the divine visage beneath. The statue is considered a work of the latter part of the Heian period and is an interesting example of the sometimes uncertain relationship between portraits and images of worship.

SHAN-TAO

Shan-tao (Zendō, 613–81) established the fundamental principles of the Pure Land creed in China, emphasizing the importance of the prayer formula of Amitābha (Amida), who is the Buddha of the Western Paradise, and the nature of rebirth in the Pure Land. The teachings of the Chinese monk greatly influenced the development of the Japanese Pure Land (Jōdo) sect, for Hōnen established the sect in Japan after having been inspired by Shan-tao's commentary on the sutra of Amitābha. In Jōdo

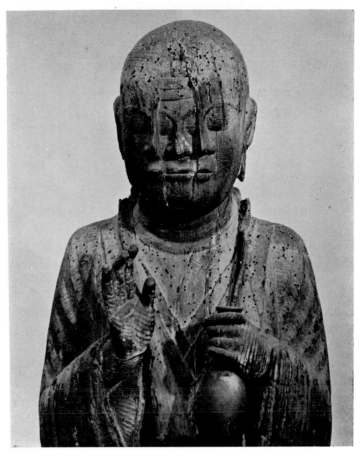

60. Pao-chih (Hōshi). Detail. Late Heian. Saiō-ji, Kyoto.

temples it is still a common custom to install images of Shan-tao and Hōnen on either side of the main object of worship.

A popular legend concerning Shan-tao was that light would issue forth from his mouth whenever he uttered the *nembutsu,* the prayer formula of Amitābha. In Japan, this prayer formula took the form of six characters: *Na-mu-a-mi-da-butsu* ("I put my faith in Amitābha Buddha").

The most commonly seen representations of Shan-tao in Japan are either standing or seated, hands held in a gesture of worship, with the mouth slightly open as if chanting. The chanted *nembutsu* is represented quite literally by six small figures of Amitābha issuing from his mouth along with rays of light. Many of these statues have lost their miniature Amitābha figures, but there are small holes in the mouths where the wire linking the small figures had once been inserted. Works similar to this exist in the Chion-in in Kyoto (pl. 25), the Zendō-ji in Fukuoka, and the Shōrin-ji in Hyōgo Prefecture. It should also be noted that representations of the popular Pure Land monk Kūya (pls. 76–77) and of the Tendai monk-scholar Sengan Naiku (pl. 61) also depict the subjects chanting mantras, and the statue of Kūya retains the small Buddha figures symbolizing the mantra.

There are also representations of Shan-tao in a slightly different form, acutely observed, with a fleshy face, mouth tightly shut, and a generally dignified appearance.

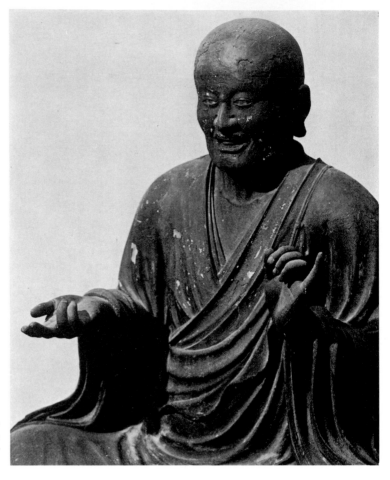

61. Sengan Naiku. Detail. Painted wood. H. 82.7 cm. Early Kamakura. Atago Nembutsu-ji, Kyoto.

The hands are not joined together in prayer but, instead, a fly whisk *(hossu)* is held in the right hand. Some examples of this type are the image thought to represent Shantao in a painting of the five founders of the Pure Land sect in the Nison-in in Kyoto, and two works that appear to have been based on it, the wooden portrait in the Kōmyō-ji in Nara and the painting in the Mandara-ji in Aichi Prefecture.

Not all of the extant Shan-tao representations fall neatly into these two forms, and images exist that appear to have combined elements of both. For example, the statue in the Raigō-ji in Nara (pl. 34) is represented with its hands held in a gesture of worship and is shown chanting as in the first form, but the figure is seated in the unusual posture of ease. Its surprisingly large features lend to it an almost heroic character that is more in keeping with works in the Nison-in tradition.

EN NO OZUNU

Also commonly known by the names En no Gyōja, En no Ubasoku, and (posthumously) Shimpen Daibosatsu, En no Ozunu (b. 634) was the Nara-period founder of *shugendō,* an ascetic Buddhist discipline whose purpose was not to study doctrine but to undergo religious austerities in the mountains, and the story of his life has been embellished with superhuman legends.

While En no Ozunu is an actual person mentioned in the *Shoku Nihongi* (Continua-

62. En no Ozunu, by Keishun.
1286. Private collection.

tion of the Chronicles of Japan from A.D. 697 to 791), his images were not produced until the Kamakura period, when the Shugendō sect became formally established; his portraits are thus imaginary. He was usually represented wearing a hood, a short garment, and high wooden clogs, and seated on a rocky ledge holding a monk's staff in his right hand and a scroll in his left. He was at times shown also with a long beard or accompanied by two demons called Zenki and Kōki. Among his portraits made in the Kamakura period are those in the Sakuramoto-bō in Nara, the Ishiba-ji in Shiga Prefecture, and the work dated 1286 by the sculptor Keishun in a private collection in Nara (pl. 62).

THE DEIFIED PRINCE SHŌTOKU

The singular contributions of Shōtoku Taishi (574–622)—that is, Prince Shōtoku—to the spread and development of Buddhism in Japan have assured an important place for him in the collective memory of the Japanese. His charismatic personality had such great appeal that during the Kamakura period he was deified and worshiped as an avatar of the Bodhisattva Avalokiteśvara. The great popularity of the cult of Shōtoku Taishi over many centuries resulted in the production of a large number of visual representations of him according to a gradually systematized iconography, which tended to depict him in an idealized manner because of his quasi-divine status.

67

Shōtoku Taishi was born the second son of the emperor Yōmei (r. 585–87). Renouncing his succession, he dedicated himself to public duty and spiritual matters, and remained a layman. Among his accomplishments were the establishment of the system of court ranks in twelve grades, his supposed proclamation of the "constitution" in seventeen articles, and his unceasing efforts for the advancement of Buddhism through the study of sutras and the foundation of monasteries. He is revered as Japan's first idealist and man of culture.

The cult of Shōtoku Taishi is an ancient one: on the remaining fragments of the Tenjukoku embroidery, which was made soon after the death of the prince, there appears a four-hundred character inscription that purports to be the oldest documented Taishi legend. Texts recording these legends that appeared through the first part of the Nara period are included in the *Nihon shoki* (Chronicles of Japan; 720). The *Shōtoku taishi denryaku,* compiled in 917, is a compendium of Taishi legends appearing in the latter part of the Nara period and the early part of the Heian period. The *Denryaku* in particular has served as a basis for pictorial biographies and representations of Shōtoku Taishi. A painted portrait of Shōtoku flanked by two princes, believed to be a work of the first part of the Nara period, still exists today in the Imperial Household Collection (pl. 63). In the painting hall of Shitennō-ji in Osaka, a temple founded by the prince himself, there apparently had once been a wall depicting the Taishi legends, dating from the latter part of the Nara period.

Originally, the cult of Shōtoku Taishi was centered mainly in temples founded by him or otherwise closely associated with him. As the creed grew in strength, it came to be adopted by a wide range of sects, each adapting it to suit its own needs. In the Tendai sect, for example, Shōtoku Taishi was called the reincarnation of Hui-ssu, the second Chinese patriarch of the sect, and was included in the Tendai genealogy. Thus, the young Shōtoku Taishi is depicted along with the patriarchs of the Tendai sect in a set of scrolls in the Ichijō-ji in Hyōgo Prefecture dating from the latter part of the Heian period.

In the Kamakura period, Shōtoku Taishi was widely worshiped in connection with a distinctive form of popular Buddhism centered in part on the monk Eizon of the Saidai-ji, who led the revival of the conjoined Shingon and Ritsu sects. Many images of Shōtoku Taishi were produced in connection with this Shingon-Ritsu movement, and also in connection with the newer Jōdo Shin sect. Over a long period of time, devout Japanese came to regard Shōtoku Taishi as a kind of intercessor on their behalf with the Buddhist deities, for he himself had been a Japanese who had fervently sought salvation. An indication of the degree to which the cult of Shōtoku Taishi had penetrated the stratum of the common people in more recent times is his designation as the protector of carpenters from the Muromachi period (1392–1572) onward, as is seen in Taishi images holding a carpenter's square.

Representations of Shōtoku Taishi can be divided into three main categories: the *namu butsu* (mantra chanting) image, the *kōyō* (offering filial piety) form, and the

sesshō (prince regent) image. Interestingly enough, these types represent the infancy, youth, and manhood of the prince. The basis for these separate forms probably exists in compendia of Taishi legends, such as the *Shōtoku taishi denryaku,* and in the pictorial biographies extant at the time.

The *namu butsu* image represents the prince as an infant and is derived from the legend that he chanted a mantra while facing eastward when he was just two years old. Ordinarily, this form is characterized as a small child wearing only a red formal split skirt with the upper half of its body bare, holding his hands in prayer (pls. 64–65). This type was probably influenced by *tanjō butsu,* images of the infant Śākyamuni. The personal history of Shōtoku Taishi, who was born the son of an emperor, resembles that of the historical Buddha, who was also a prince; and Taishi legends were elaborated in much the same pattern as the legends of the historical Buddha.

The *namu butsu* form became particularly popular during the Kamakura period, and its innocent quality seems to have had universal appeal. The oldest dated statue (pl. 65), now in an American private collection, has internal documents inscribed with the year 1292. The oldest of the works still in Japan is enshrined in the Okubo-

63. Shōtoku Taishi flanked by two princes. Colors on silk. Nara period. Imperial Household Collection.

64. *Namu butsu* form of Shōtoku Taishi. Painted wood. Kokubu Shōtoku Taishi Kai.

65. *Namu butsu* form of Shōtoku Taishi. Painted wood. H. 67.6 cm. Dedicated in 1292. Sedgwick Collection, U.S.A.

dera in Nara, signed by the sculptor and dated 1300. Both of these statues fall into the late Kamakura period, but the type must have appeared at least a century earlier, for there is an entry made in 1210 in a Kamakura-period historical record, *Azuma kagami,* referring to a memorial service held for a *namu butsu* image in the private devotional chapel of the shogun Minamoto no Sanetomo.

The *kōyō* (offering filial piety) image was the most frequently produced of the three forms. Shōtoku Taishi is here represented as a youth with his hair still tied in loops, wearing boots and a coat with a monastic surplice over it, standing and holding an incense burner by its long handle (pl. 66). It is likely that this form is based on a passage in the *Shōtoku taishi denryaku* stating that at age sixteen, the young prince, while holding an incense burner, prayed for the speedy recovery of his father, the emperor.

Variants of this type of image occur: some figures hold a fan or scepter rather than an incense burner, some are not shown with a surplice, and others are seated rather than standing. Although these variations still represent Shōtoku Taishi as a youth, they are not strictly filial images. The statue of the prince dated 1069 and now in Hōryū-ji (pl. 67) is not wearing a surplice, can hold a removable round fan, and is seated. It is believed to have been the main object of worship for the *shōryō-e,* the annual memorial service in honor of the prince. This particular form is reputed to be a representation of the seven-year-old Shōtoku Taishi perusing sutra texts brought

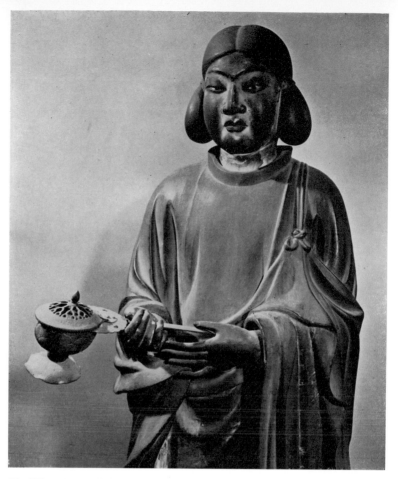

66. Filial form of Shōtoku Taishi at age sixteen, by Kenshun. Detail. Painted wood. 1268. Gokuraku-bō, Gangō-ji, Nara.

from the Korean kingdom of Packche (Japanese: Kudara). It is probable that originally there were various kinds of images of the young Shōtoku Taishi, but that the most popular were filial statues.

Other variants of the filial form reflect the aesthetic atmosphere of the late Heian period in which religious influences worked to invest youthful representations of Shōtoku Taishi with attributes generally associated with the historical Buddha Śākyamuni and the Bodhisattva Avalokiteśvara (Kannon). The painting of Shōtoku Taishi in the series of portraits of patriarchs of the Tendai sect dating from the latter half of the Heian period in the Ichijō-ji can be described as a filial image, for the young prince is shown wearing a monastic surplice and holding an incense burner. The figures of ten small boys facing him in an attitude of worship are, however, an arrangement reminiscent of the Ten Great Disciples of Śākyamuni. It is likely that the boy prince Shōtoku was identified with the young Śākyamuni, and that Prince Shōtoku as a youth was considered a bodhisattva before enlightenment. The Ichijō-ji painting also depicts Shōtoku Taishi seated in the posture of ease, which is associated with Cintāmaṇi-cakra Avalokiteśvara (Nyoirin Kannon). In the late Heian period, Shōtoku Taishi was believed to have been an incarnation of the two-armed Cintāmaṇi-cakra Avalokiteśvara, for the graceful countenance of the bodhisattva was thought to be reflected in the features of the youthful Japanese prince.

71

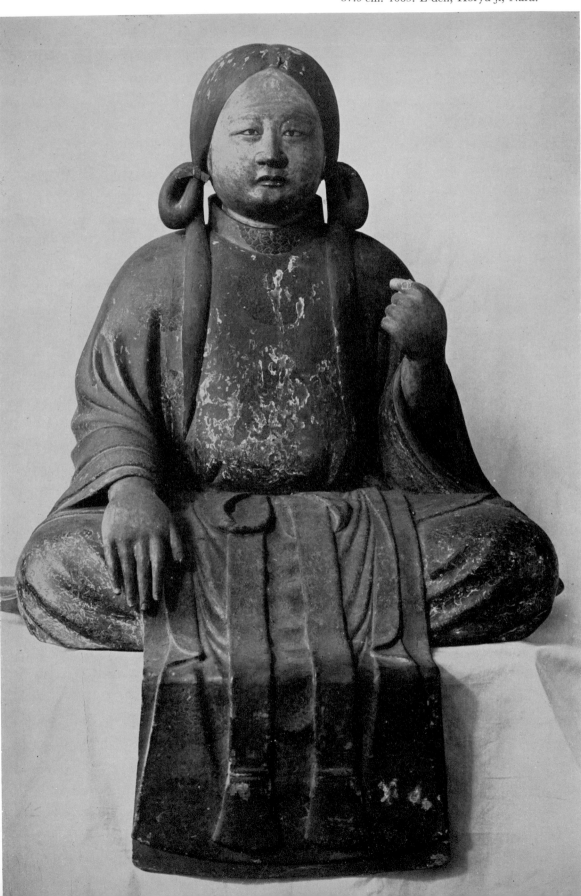

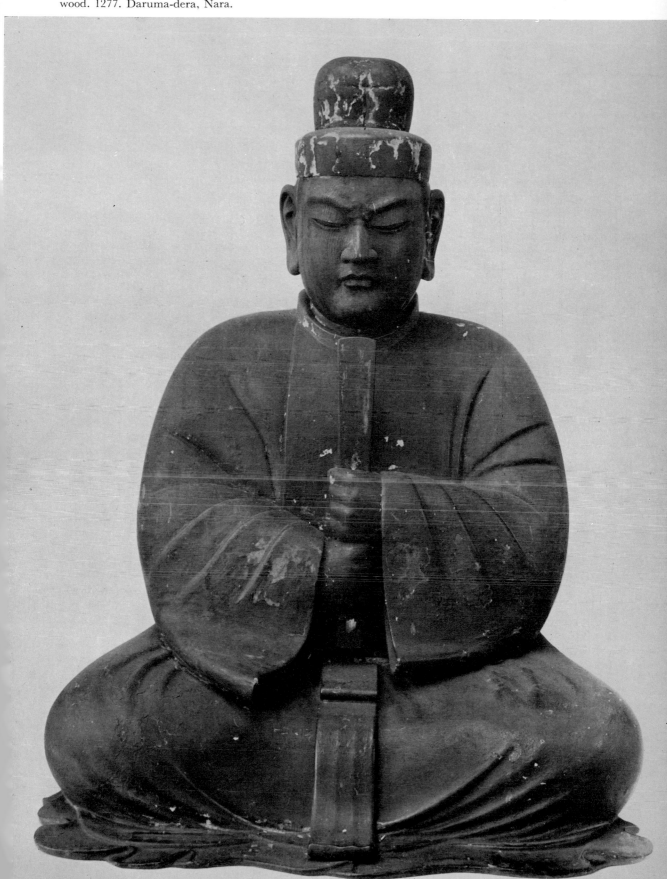

68. Prince regent form of Shōtoku Taishi at age thirty-two, by Inkei and Indō. Painted wood. 1277. Daruma-dera, Nara.

A scroll dated 1163 depicting venerated monks, which is kept in the Ninna-ji in Kyoto, contains a representation of the filial Shōtoku Taishi. The young Shōtoku Taishi may have been included among and treated with the same respect as the revered monks of the past because of the general preference for the youthful representation of the prince over either of the other forms and the fact that the prince as a youth was associated with both the historical Buddha Śākyamuni and the two-armed Cintāmaṇi-cakra Avalokiteśvara.

The third main category of Shōtoku Taishi representations is that of the prince regent, showing him as an adult, seated wearing a coat and hat, holding a scepter (pls. 13, 68). There are numerous examples of this form, which is universally believed to be a depiction of the prince at the age of thirty-two, when he established the twelve-rank court system—one of his greatest accomplishments. The oldest version of this type is the painting now in the Imperial Household Collection dating from the first part of the Nara period, in which he is represented standing accompanied by two lesser princes (pl. 63). The earliest sculpted work is a seated image with four attendants enshrined in the Shōryō-in of Hōryū-ji (pl. 13), known to date from the late Heian period.

A group of images related to the prince regent form depicts Shōtoku Taishi lecturing on the *Shōman-gyō,* a text concerned with the salvation of lay persons, especially women. In sculptural representations, this form does not greatly differ from that of the prince regent, for he is seated wearing a coat, but a surplice is worn over the coat, a pendant hangs from his headgear, and he holds a round fan. A setting is provided in paintings of this scene: he is shown as above, sitting in front of a desk on which a sutra scroll is unrolled, and he has an audience including Prince Yamashiro no Ōe, Soga no Umako, Ono no Imoko, and the monks Kakuka and Eji (Chahye in Korean). Lotus petals scattered over the painting are also conventional. Of existing works, there are paintings that date as early as the Kamakura period, but there are no extant sculptures of the lecturing prince dating before the Muromachi period, the earliest being an image in the Nakayama-dera in Hyōgo Prefecture. The extant examples seem to indicate that works depicting the sutra lecture appear only with the Kamakura period, but literary evidence suggests otherwise. Documentary evidence occurs as early as the eighth century: the record of the holdings of the Eastern Precinct of Hōryū-ji dated 761 contains an entry on the reverse of the front cover describing a drawing of Hōō (King of the Law), another name for Shōtoku Taishi, appended to a transcription of the *Shōman-gyō.* It is, of course, impossible to reconstruct that drawing, but it is likely that it was related to the representation of the lecturing Taishi of later generations. Since the filial image is known to have existed already in the latter part of the Heian period, it would not be surprising if the prince regent and lecturing Taishi forms were produced at a comparable date or even earlier.

3

PORTRAITS
OF HISTORICAL PERSONAGES

Portraits of historical personages have subjects who belong to the more recent past.
Records concerning most of them still exist, and many have been given standard
biographies. However, these men were frequently venerated monks and founders of
religious sects, and their portraits tended to be subjected to the myth-making process
in direct proportion to the degree of their sanctity and the amount of time elapsed
since their death. Thus it is not necessarily true that the representations of these
subjects are more realistic in character than those previously discussed, although they
are more firmly grounded in historical fact. In actuality, the styles of these works
cover much the same range as the imaginary portraits: from the idealistic manner
associated with Buddhist objects of worship to the realistic treatment that is in keep-
ing with true portraiture. The specific form of each work was determined by the
character of the sect involved, the requirements of the commissioners of the portrait,
and the traditionally accepted mode of portrayal of the particular subject, tempered
by the artistic climate of the period in which it was produced. Representations of
historical personages most often fulfill, however, the requirements of true portraiture,
that is, the depiction of the subject in his own individual character.

GYŌKI

One of the celebrated monks of the Nara period, Gyōki (670–749) is revered not only
for his religious accomplishments but also for his social welfare activities. Sculptures
and paintings representing Gyōki remain in a number of temples related to him in
Nara and elsewhere. In the Nara temples of Tōshōdai-ji and Yakushi-ji are wooden
portrait statues dating from the Kamakura period. Gyōki had entered the Yakushi-ji
as a novice and had studied there. The portrait in the Tōshōdai-ji (pl. 69) is be-
lieved to have been originally enshrined in the Chikurin-ji on Mount Ikoma, a
temple built near the grave of Gyōki, but was transferred to the head temple, Tōshō-
dai-ji, when Chikurin-ji began to decline.

GANJIN

Ganjin (Chien-chen, 688–763), who established the Japanese Ritsu *(vinaya)* sect, is also the founder of the Tōshōdai-ji. He was, however, originally from China, born in Yangchou, and was induced by visiting Japanese monks to transmit the formal monastic precepts to Japan. He reached the Tōdai-ji in 754 after having spent eleven years attempting to cross the ocean, suffering many hardships and losing his eyesight in the process. After his death in 763, he was posthumously named Kakai Daishi (the Great Master Who Crossed the Seas) and Tō Daiwajō (the Great Master from T'ang). His biography, *Tō daiwajō tōsei den,* was written by his disciples.

The most famous portrait of Ganjin is the dry-lacquer statue in the Tōshōdai-ji in Nara (pls. 5–6). Ganjin died in the summer of 763, and in the spring of that year it is said that one of his disciples dreamed that a beam in the lecture hall of the monastery had broken, interpreted the dream as a premonition of the death of his master and so commissioned the image. Ganjin is represented seated with his hands in the gesture of meditation. Since both eyes are quietly shut, the sculpture indicates what must have been his actual appearance, for it is to be remembered that the Chinese monk lost his eyesight in one of his attempts to reach Japan. The surplice is decorated with a *tōyama* (distant mountain) motif, a small scalloped pattern somewhat resembling a mountain range. In addition to this work, other painted and sculpted representations of Ganjin exist today. However, they all date to the Kamakura period or later and are based on the Tōshōdai-ji portrait.

KŪKAI

Also known by the posthumous title Kōbō Daishi, Kūkai (774–835) was one of the foremost Buddhist leaders of the Heian period, widely known for his intellectual and artistic as well as spiritual achievements. Dissatisfied with the manner in which Buddhism was presented in Japan, he left for China in 804 in search of a more meaningful system. He was accepted there as a disciple of the esoteric master Hui-kuo, and was initiated into the doctrines and precepts of Shingon. Upon his return in 806, he introduced this new sect to Japan, bringing with him many esoteric sutra texts, ritual manuals, Buddhist images, mandalas, and implements for worship. He established the Kongōbu-ji on Mount Kōya and was later placed in charge of the Tō-ji in Kyoto, making these the main centers of his sect.

The painting of Kūkai in the *eidō* (portrait hall) on Mount Kōya is said to have been executed during his lifetime and to be his oldest portrait; it is kept concealed because of its highly sacred character, so that its actual characteristics are unknown. Aside from this, the oldest extant portrayal of the monk is probably the wall painting in the five-storied pagoda of the Daigo-ji in Kyoto, representing the eight patriarchs of the Shingon sect, of which Kūkai is one. The pagoda was originally built in 951, so the painting would date approximately from that time. The image of Kūkai is in

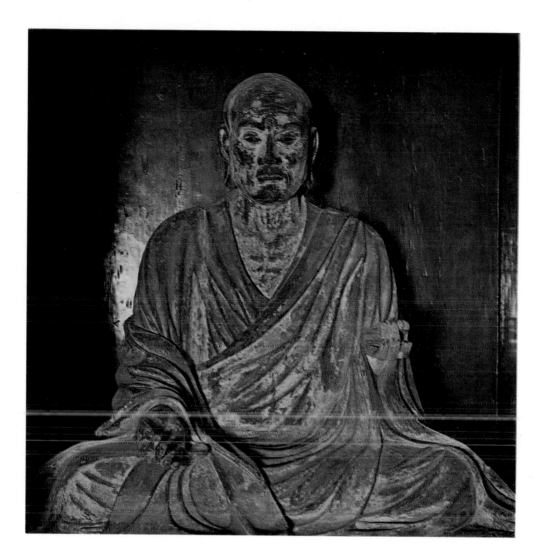

69. Gyōki. Painted wood. H. 85.2 cm. C. 1249. Tōshō-
dai-ji, Nara.
This portrait of the Nara-period monk Gyōki is thought
to have been made on the five-hundredth anniversary
of his death, about 1249. The style of the work is con-
sistent with such a date: the countenance, attitude, and
drapery of the subject have been rendered realistically,
but the overall treatment has hardened somewhat, sug-
gesting a date in the mid-Kamakura period.

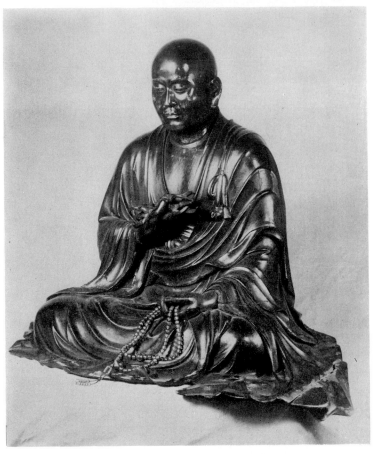

70. Kūkai, by Kōshō. Paint-
ed wood. H. 83.3 cm. 1233.
Miei-dō, Tō-ji, Kyoto.

bad condition, but he is shown with a round, boyish face, holding a rosary in his left
hand—the form of Kūkai still familiar to most Japanese. He seems to have originally
held a five-pronged *vajra* in his right hand and was seated on a low dais with shoes
and water jar placed to the side. Excluding Kūkai, the portraits of the eight patriarchs
in this pagoda were modeled on those in the Tō-ji in Kyoto, of which five were paint-
ed in China during the T'ang period and two in Japan during the Heian period.
The painting of Kūkai can be thought to have been executed with the Tō-ji works in
mind, for the folding stool, shoes, and water jar reflect conventions already established
in the Tō-ji portraits.

Extant sculptures, on the other hand, are all products of the Kamakura period or
later. It appears that wooden images of Kūkai had existed in the Heian period, for
according to records, there seem to have been such figures enshrined in the Anshō-ji
in Uji and in the *kondō* of the Kongōbu-ji. The sculpted portraits are similar to the
painted ones: the faces are often plump and round, a five-pronged *vajra* is held in the
right hand directly in front of the chest, and the left hand is lowered slightly and holds
a rosary (pls. 12, 20, 30–31, 70, 71). The figure is usually seated, on a low dais in
front of which are placed his shoes, with the water jar to the side. It is natural to sup-
pose that the sculpted portraits of Kūkai were derived from the painted images.

In the *eidō* at Tō-ji is enshrined the portrait of Kūkai shown in plate 70, carved by
Kōshō, the fourth son of the master sculptor Unkei, completed in 1233. This statue is

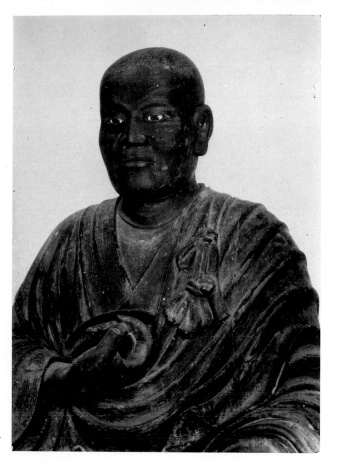

71. Kūkai. Detail. Painted wood.
Late Kamakura. Senju-ji, Kyoto.

of remarkable quality, carved by the sculptor at the peak of his maturity and executed in a highly realistic technique, with a skillful treatment of the complicated drapery folds. Though carved in a realistic style, this statue was created four hundred years after the death of the subject, and probably bears little resemblance to Kūkai himself. In addition, the portrait was intended to serve as the object of worship of a cult, and was therefore to some extent idealized. This work is the most outstanding portrait of Kūkai, and many representations of the venerated monk can be thought to have been based on it.

In Rokuharamitsu-ji in Kyoto is a work inscribed by the sculptor Chōkai, a disciple of Kaikei. A likely date for the statue would fall in the Kenchō era (1249–56), roughly twenty years after the production of the Tō-ji portrait. Also in the realistic tradition of the Kei school, this work manifests many of the positive characteristics of the earlier years of the Kamakura period, and has not yet succumbed to the hardening of forms that was to occur in later decades.

Other kinds of Kūkai images appeared as his cult became widely diffused and popularized. He was shown, for example, as a child *(chigo)*, as an ascetic *(shugyō)*, and, demonstrating the efficacy of the Shingon teachings, in his own enlightened state *(nichirin)*. However, since most of these images are objects of worship of popular cults, they are usually not of high aesthetic value, with the exception of some paintings of the child Kūkai.

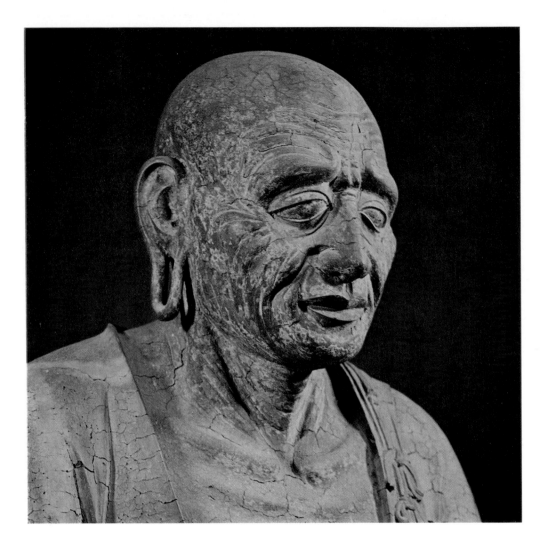

72. Gien. Detail. Painted wood. H. 90.9 cm. Early
Heian. Oka-dera, Nara.
Though executed in a technique that came to be used
at the end of the early Heian period, this statue reflects
the realistic style of the Nara ateliers to such an extent
that some scholars have dated it to the Nara period.
It is assembled using one large block for the upper body,
separate pieces for the hands, and smaller blocks joined
together to form the lower half, with lacquer coating
and a final covering of paint. This statue is not a portrait
in the strict sense; rather it depicts the subject as an
ascetic holy man, resembling the images of arhats. (For
full view see pl. 93.)

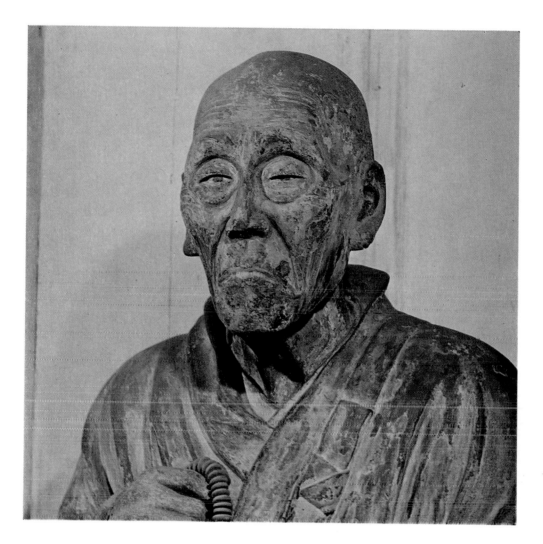

73. Chōgen. Detail. Painted wood. H. 82.4 cm. C. 1206. Shunjō-dō, Tōdai-ji, Nara.

An uncompromisingly realistic portrait without a trace of idealization, this representation of Chōgen is one of the finest examples of true portraiture in the history of Japanese sculpture. Unlike any of its immediate predecessors, this statue imparts a strong individualistic quality, and marks a new sensibility emerging in the portraiture of the Kamakura period. Considering Chōgen's strong commitment to the rebuilding of the Tōdai-ji and his patronage of the sculptor Kaikei, it is likely that this work was executed by a member of the Kei school shortly after the monk's death in 1206. (For full view see pl. 81.)

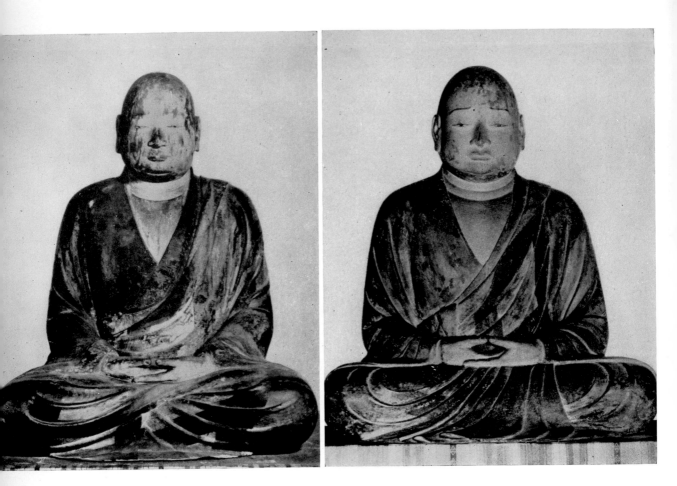

ENCHIN

Posthumously named Chishō Daishi, Enchin (814–91) was the fifth abbot of Enryaku-ji, the founder of the Onjō-ji and the Jimon subsect of Tendai esoteric Buddhism. The two basic portrait statues of Enchin are the so-called Sannō-in Daishi and Okotsu Daishi. The former is found today enshrined within the founder's hall in the Kara-in of Onjō-ji in Shiga Prefecture (pl. 75) and was believed to have been made immediately after Enchin's death. It was originally kept in the former monastic dwelling of Enchin on Mount Hiei, the Sannō-in, and later moved to Onjō-ji. The other statue (pl. 74) is enshrined in the same founder's hall of Onjō-ji facing the first figure. According to tradition, this work was made soon after the death of the monk, and his ashes were placed within the image, so it came to be known popularly as the Okotsu (Bone Relic) Daishi statue. Although both works are traditionally dated shortly after 891, a comparison of the techniques of the two images shows that they could not have been contemporary. Opinions vary with regard to the dating, but the Okotsu Daishi can be regarded as a work made immediately after the death of Enchin, while the Sannō-in Daishi manifests later characteristics.

Both images depict the subject with hands in the gesture of meditation, seated cross-legged, and both have peculiarly egg-shaped heads. This is a physical charac-
teristic of the monk recorded in the *Chishō daishi den,* a biography compiled by En-

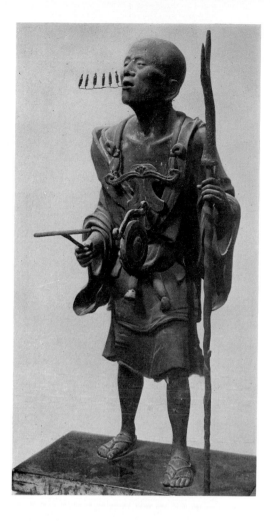

74. Enchin ("Okotsu Daishi"). Painted wood. H. 85.1 cm. Made shortly after his death in 891. Kara-in, Onjō-ji, Shiga Prefecture.

75. Enchin ("Sannō-in Daishi"). Painted wood. Kara-in, Onjō-ji, Shiga Prefecture.

76. Kūya, by Kōshō. Painted wood. H. 117.6 cm. Before 1207. Roku-haramitsu-ji, Kyoto. (See also pl. 77.)

chin's lay disciple Miura Seigyō. Both of these works are similar in general appearance, but if one looks at the details, disparities can be seen in the carving of the drapery and the manner in which the folds of the robe are arranged.

Portraits of Enchin made in later periods use one or the other of these statues as a model. For example, the portrait in the Shōgo-in in Kyoto (pl. 9) was copied from the Sannō-in Daishi by the Buddhist sculptor Ryōkai in 1143. The statue in the Kyoto Nyakuō-ji is a late Heian-period work sculpted after the Okotsu Daishi. Whichever model was followed, the characteristically egg-shaped head was reproduced, as well as the general form and treatment of the garment folds.

Kūya

Kūya (903–72) occupies an important place in the history of Japanese Buddhism for his work in spreading the teachings of the Pure Land among the populace through advocacy of the *nembutsu*. The best-known portrait sculpture of Kūya is the image made by the Buddhist sculptor Kōshō in the first decade of the thirteenth century (pls. 76–77). This work has very specific attributes: the monk is shown wearing a short garment and straw sandals, holding a "deer staff" in his left hand, and striking a bell hung from his neck with a hammer in his right hand. Of particular interest are the six

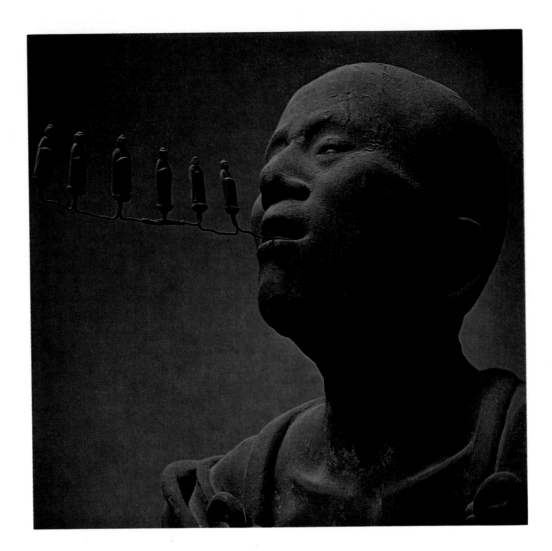

77. Kūya, by Kōshō. Detail. Painted wood. H. 117.6 cm.
Before 1207. Rokuharamitsu-ji, Kyoto.

Carved by Kōshō, the fourth son of Unkei, this figure
of the peripatetic monk of the tenth century, Kūya,
captures him as he goes on a pilgrimage while chanting
the six-character *nembutsu*, represented by the small
figures of Amitābha issuing from his mouth. Rather than
communicating the character of the subject by empha-
sizing his facial features, his entire physical form has
become an expression of his religious zeal. It exhibits
a fresh, innovative approach to the problem of repre-
senting a charismatic historical personage. (For full
view see pl. 76.)

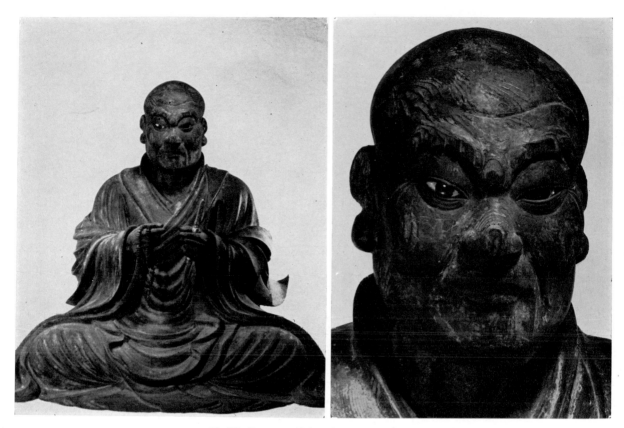

78–79. Ryōgen. Painted wood. H. 84.2 cm. 1268. Manju-in, Kyoto.

small figures of Amitābha issuing from his open mouth, a physical representation of the six-character *nembutsu*. As has been previously discussed, a similar treatment of the *nembutsu* could be seen in the portrait of the Chinese Pure Land patriarch, Shan-tao, which perhaps served as a basis for this practice in the image of Kūya. This statue depicts the monk on a pilgrimage, chanting as he walks. Rather than communicating the character of the subject by emphasizing his facial features, his entire physical form has become an expression of his religious zeal. Sculpted portraits of Kūya depicted in a similar manner can also be found in the Sōgon-ji in Shiga Prefecture and in the Jōdo-ji in Ehime.

RYŌGEN

Ryōgen (912–85), or Jie Daishi, was responsible for the rejuvenation of both the Tendai sect and Enryaku-ji, its headquarters on Mount Hiei near Kyoto. On the anniversary of his death, the so-called *ganzan-e* occurs at Yokawa on Mount Hiei. *Ganzan* literally means third day of the first month, the day Ryōgen is said to have died. The term *ganzan* has also come to be applied to a charm on which a picture of Ryōgen in the shape of a demon is printed, and Ryōgen is also commonly known as Ganzan Daishi.

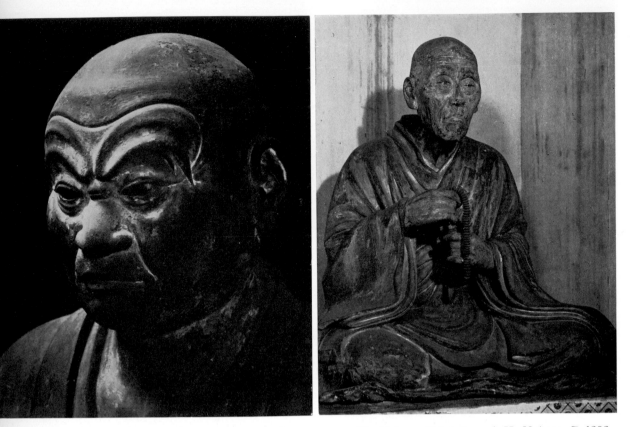

80. Ryōgen. Detail. Painted wood. H. 78.2 cm. 1267. Shōbō-ji. Kyoto.

81. Chōgen. Painted wood. H. 82.4 cm. C. 1206. Shunjō-dō, Tōdai-ji, Nara. (For detail see pl. 73.)

From early on, Ryōgen was believed to have been the incarnation of a divine being, and there was a widespread belief that he had the power to exorcise evil spirits. Consequently, representations of him in painting, prints, and sculpture were extremely popular, and there are numerous such objects extant today. There were sculpted images of Ryōgen made in 1204–5 for each of the three pagodas on Mount Hiei. These have unfortunately not survived, but their existence is recorded in temple records. Of extant works, the oldest sculpture is inscribed with the date 1218, slightly later than the lost Mount Hiei statues, and is now in the Genkō-ji in Hyōgo Prefecture. There are numerous Ryōgen portraits remaining that are of later date, but these are practically identical in form. They are seated images, holding a one-pronged *vajra* in the left hand, or else grasping a rosary with both hands, and they have particularly imposing features, reflecting the nature of a monk believed to have been able to conquer evil spirits. Two interesting late Kamakura-period portraits, one in the Manju-in (pls. 78–79), the other in the Shōbō-ji (pl. 80), both in Kyoto, are noteworthy examples. Although it is common for painted portraits of Ryōgen to show unusually long eyebrows, sculpted representations of the monk often lack this particular characteristic, which may have been omitted for technical reasons.

CHŌGEN

Shunjōbō Chōgen (1120–1206) assumed the name Namu Amida Butsu when he con-

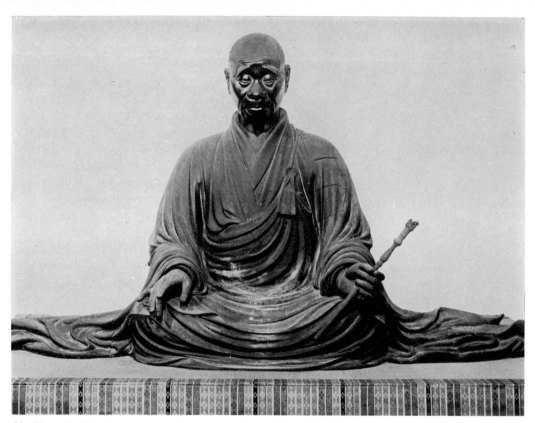

82. Eizon, by Zenshun. Detail. Painted wood. H. 89.3 cm. 1280. Saidai-ji, Nara. (For detail see pl. 8.)

verted from Shingon to the Jōdo sect. He visited Sung China three times and was instrumental in transmitting the Sung style of art and architecture to Japan. He is best known for having rebuilt the Tōdai-ji in Nara, which had burned down in 1180 during the Gempei wars.

Portraits of Chōgen can be thought to have been made during his lifetime. The *Namu Amida Butsu sazenshū* (Compilation of Virtuous Deeds of Namu Amida Butsu [Chōgen]) records that Chōgen had sent building materials and a sculpted as well as a painted portrait of himself to China for the rebuilding of a reliquary hall of the monastery on A-yü-wang-shan near Hangchou. Of extant wooden portrait sculptures in Japan, those in Amida-ji in Yamaguchi Prefecture and the Shin Daibutsu-ji in Mie Prefecture appear to have been made while Chōgen was in the process of building each of these temples. Of the two portraits, the subject of the latter appears to be somewhat older than that of the former, and this matches the difference in age of the two temples. Both are seated images, but the former has his palms pressed together in a gesture of worship, while the latter has both hands clenched.

The portrait in the Shunjō-dō of Tōdai-ji (pls. 73, 81) was probably made immediately after Chōgen's death for his memorial services. This portrait indicates his appearance in the last years of his life. He is shown seated holding a rosary in both hands, a pose differing from that of the two works previously discussed. The image in the Jōdo-ji in Hyōgo Prefecture is of a similar type and may well have been modeled after the Tōdai-ji portrait. Chōgen was represented in a number of different ways.

The likenesses made during his lifetime did not yet possess the religious quality of objects of worship and were, as a result, freely portrayed. After his death, however, as can be seen in the Tōdai-ji and Jōdo-ji works, a definite type was fixed, based on his actual appearance in his late years, and was given a religious meaning.

EIZON

Known also by the posthumous title of Kōshō Bosatsu conferred by the imperial court, the monk Eizon (or Eison, 1201–90) converted to the doctrine of the *vinaya* from esoterism and determined to revive the ancient Ritsu sect. He worked for the restoration of the Saidai-ji in Nara and became active in the dissemination of the Ritsu canons in temples of several provinces.

The seated sculpture of Eizon in the Saidai-ji (pls. 8, 82) was carved by the Buddhist sculptor Zenshun in 1280, when Eizon was seventy-nine years of age. It is, in every sense of the word, the fundamental work among portraits of Eizon. He is shown seated, holding a monk's "fly whisk" in his left hand, and both of his sleeves are extremely long, extending out on both sides. An exact copy of this work was produced by the sculptor of the portrait of Eizon in Gokuraku-ji in Kanagawa Prefecture. The particular treatment of the sleeves influenced portrait sculptures in sects other than the Ritsu. The extremely complicated drapery and the use of highly conventionalized forms of depiction, such as the exaggerated elongation of the eyebrows to indicate age, are characteristics of late Kamakura-period portraiture.

PORTRAIT SCULPTURES OF THE ZEN SECT

Portrait statues of the Zen sect *(chinsō)* form a distinct category, for they are made according to specific canons distinguishing them from other portrayals of historical personages. The *chinsō* follow an established form that varies only slightly. The subjects are shown seated on chairs wearing long garments with hems hanging down considerably, and they may carry a rod or a monk's fly whisk *(hossu)* or hold their hands in the gesture of meditation. The representation of the visage, however, captures the individual character of each man, and its realistic treatment differs markedly from the simple and conventionally represented body. This contrast serves to focus attention on the face, thus making these works effective as true portraits. The communication of the character of the subject through the countenance rather than through the form as a whole or by its attributes is quite the opposite of methods of characterization used in previously discussed depictions of religious personages.

The oldest extant portrait of this type is that of Hottō Kokushi in the Ankoku-ji in Hiroshima (pls. 83–84), carved in 1275, when the subject was sixty-nine years of age. This statue, though the first known of its type, already manifests all the stylistic characteristics mentioned above. This is not surprising, however, since Japanese Zen

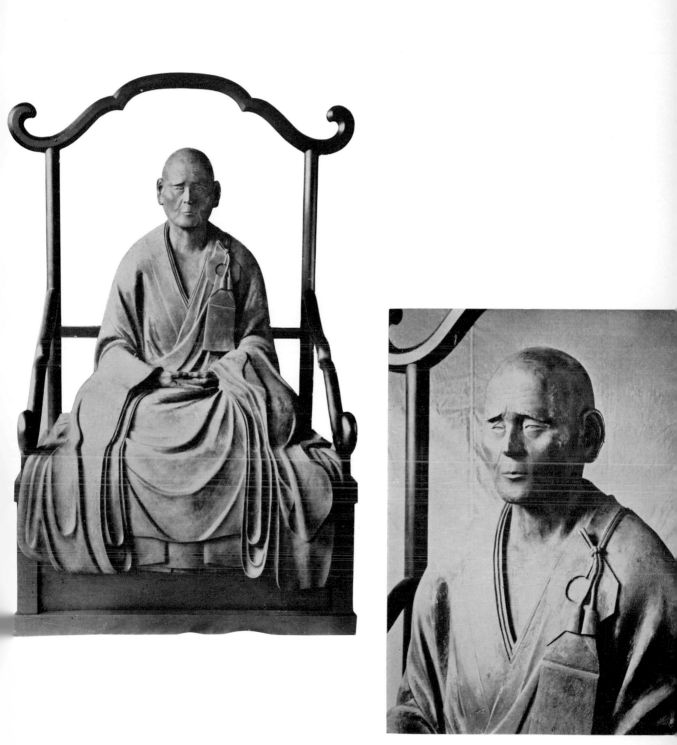

83–84. Hottō Kokushi. Painted wood. H. 82.4 cm. C. 1275. Ankoku-ji, Hiroshima.

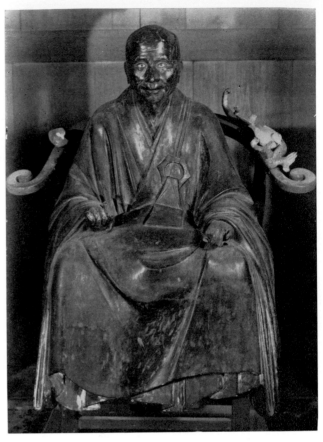

85. Bukkō Kokushi (Wu-hsiao Tsu-yüan). Painted wood. H. 63.9 cm. Made shortly after his death in 1286. Engaku-ji, Kamakura.

86. Portrait said to be of Minamoto no Yoritomo. Painted wood. H. 70 cm. Late Kamakura. Tokyo National Museum.

87. Taira no Shigemori, by Fujiwara no Takanobu. Detail. Colors on silk. H. 139.4 cm., w. 111.8 cm. Second half of the twelfth century. Jingo-ji, Kyoto.

monks studying in China often returned with painted *chinsō* of their Chinese masters. *Chinsō* paintings often served as certificates of transmission, presented by a master to his deserving disciple. The earliest recorded example is perhaps the painting of Ju-ching brought back to Japan in 1227 by Dōgen, the great Japanese pioneer of the Sōtō school of Zen.

Zen Buddhism focuses attention on the individual master as an embodiment of the Buddhist law, stresses direct transmission of the teachings, and deemphasizes scriptural authority. These characteristics influenced the forms that the sculptures took, and thus the Zen *chinsō* differs in significance from the portraits of venerated monks of other sects. Because the individual character of the Zen master is of such paramount importance and because these portraits are not meant to serve as objects of popular cult worship, the countenances of the subjects are realistic and unidealized.

Other well-known *chinsō* sculptures are the figure of Hottō Kokushi in the Kōkoku-ji, Wakayama Prefecture, carved about ten years after the Ankoku-ji portrait and also a *juzō* (image of a living person), and the statue of the celebrated Chinese Zen monk Wu-hsiao Tsu-yüan (Bukkō Kokushi, pl. 85) in the Engaku-ji in Kamakura, which is contemporary with the Kōkoku-ji work.

Lay Portraiture

Japanese portraiture from the Kamakura period onward also included lay subjects as well as representations of clergy. The best-known portrait statues of laymen are the

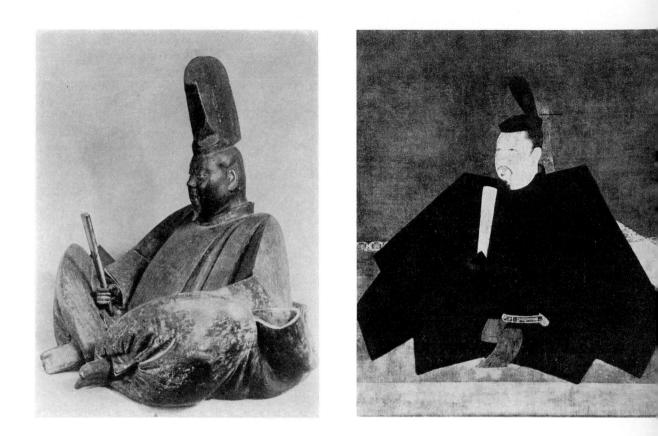

figure of Hōjō Tokiyori in the Kenchō-ji (pl. 90), that of Uesugi Shigefusa in the Meigetsu-in (pls. 88–89), both in Kamakura, and that of Minamoto no Yoritomo (pl. 86), now in the Tokyo National Museum. These statues, which are of Kamakura-period leaders, were produced in the thirteenth century in the Kamakura area, the seat of the new military regime *(bakufu)* established by the Minamoto clan. All three figures are seated, wearing ceremonial court dress and tall court headgear *(eboshi)*, and holding scepters. In opposition to the precise realism seen in the countenances, the garments are simple and schematized, so that the contrast produces an interesting sculptural effect.

Unlike the vast majority of examples heretofore discussed, these portraits find their precedent not in Chinese sculptural or pictorial styles but in the indigenous Japanese courtly artistic tradition. The best-known examples of aristocratic portrait painting are the three surviving works by Fujiwara no Takanobu in the Jingo-ji in Kyoto dating from the second half of the twelfth century (pl. 87). The tradition established by Takanobu was continued by his son Nobuzane, who specialized in portraiture, and whose technique was given the name *nise-e* (lifelike painting, or realistic portraiture). Nobuzane's descendants formed a separate school of painting specializing in this form and were active throughout the thirteenth century.

The *nise-e* tradition was firmly established before the appearance of sculpted portraits of court subjects. The earliest statue is that of Hōjō Tokiyori, probably made shortly after his death in 1263. A comparison of works in the two media immediately reveals that the statues are a rendering of *nise-e* into three-dimensional form.

91

88–89. Uesugi Shigefusa. Painted wood. H. 68.2 cm.
Late Kamakura. Meigetsu-in, Kamakura.
This is one of three outstanding portraits of lay subjects
that survive from the 1260s. The appearance of the
layman in sculpture in the late Kamakura period indi-
cates a basic change in attitude whereby portraiture was
no longer restricted to religious personages. Though the
countenance is carved naturalistically, the garments are
broadly treated and schematized, creating an interesting
sculptural contrast. Lay portrait sculpture derives from
the indigenous tradition of painted court portraits, *nise-e*,
which developed in the late twelfth century.

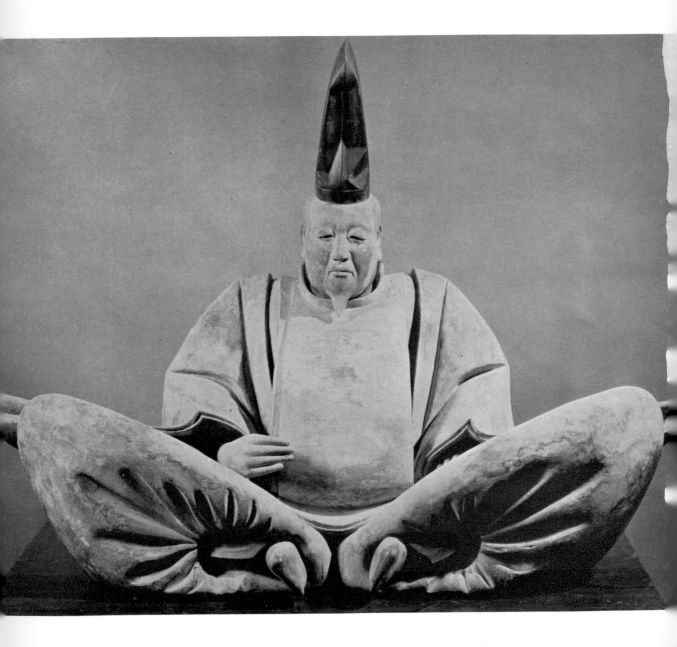

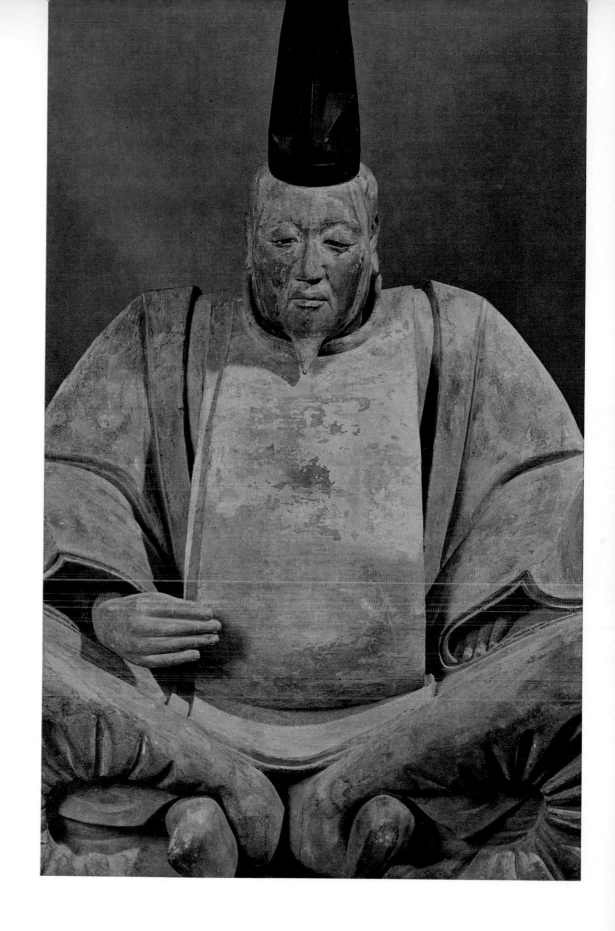

90. Hōjō Tokiyori. Painted wood. H. 74.8 cm.
Probably made shortly after his death in 1263.
Kenchō-ji, Kamakura.

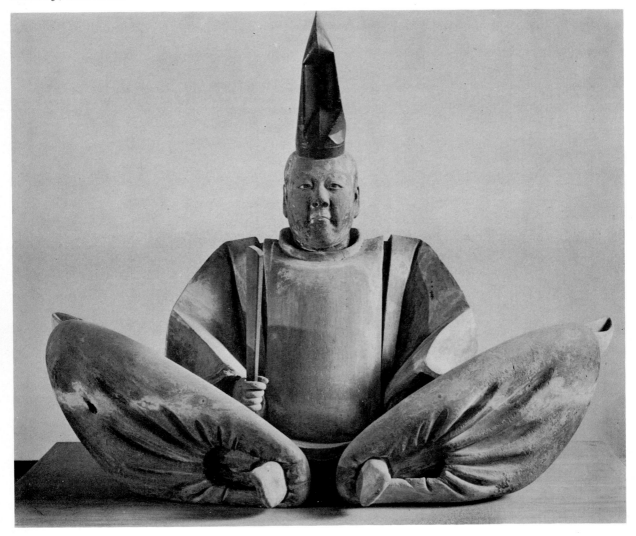

4

HISTORICAL AND STYLISTIC DEVELOPMENT

The foregoing chapters of this book have dealt with the religious background and general types of portrait sculpture, emphasizing the sociocultural rather than the art-historical aspects of the genre. In order to appreciate portrait statues from an art-historical point of view, it is necessary to study the development of portraiture within the context of the history of Japanese sculpture.

Since the history of sculpture in Japan is marked by periods of strong foreign influence, it is difficult to ascertain the extent to which Japanese portrait sculpture may have followed an intrinsic stylistic development over the centuries. It is possible, however, to trace the general trends followed in given periods, whether initiated by foreign influence or by stylistic tendencies inherent in the genre itself.

THE EARLIEST JAPANESE PORTRAIT

It is not quite clear when portrait painting and sculpture were first produced in Japan. In 626, according to tradition, a picture of Soga no Umako kneeling before Shōtoku Taishi was commissioned and displayed in front of Shōtoku's grave. This suggests that portraiture existed in some form at this early date. In fact, a painting dating only slightly later, the portrait of Shōtoku Taishi flanked by two princes (pl. 63), in the Imperial Household Collection, still exists today.

The impulse to produce portraits grew stronger in the Nara period, it seems, for the well-known portrait statues of the monks Ganjin (pls. 5–6) and Gyōshin (pls. 91–92) were produced at this time. Less formal representations, such as the cartoon-like drawings labeled *daidairon* in the Shōsō-in and the figures among the graffiti in the rafters of the *kondō* of Hōryū-ji, also begin to appear.

In the *Man'yōshū,* the Nara-period anthology of poetry, is a set of short verses, dating to the year 755, composed by frontier guards about to be dispatched to new posts. Among them is the following:

> *If only I had had the time*
> *To draw a picture of my dear wife . . .*
> *Looking at it I would long for her*
> *As I go on my journey.*

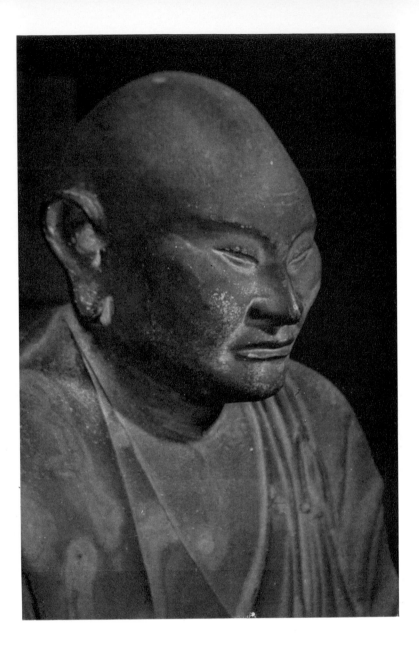

This image of a man wishing to capture his beloved in a portrait as he is about to be separated from her expresses a basic human sentiment, which is a primary motivation behind portraiture in general.

PORTRAIT STATUES OF THE NARA PERIOD

The oldest extant portraitlike sculptures include the 711 Vimalakīrti image in the group of clay figures in the base of the pagoda at Hōryū-ji (pls. 53–54) and the slightly later statues of the Ten Great Disciples in the Kōfuku-ji dated 734 (pls. 38–43). These are, however, imaginary portraits reconstructing the supposed characters of the subjects by means of a realistic mode of portrayal used widely in depicting secondary members of the Buddhist pantheon during the Nara period.

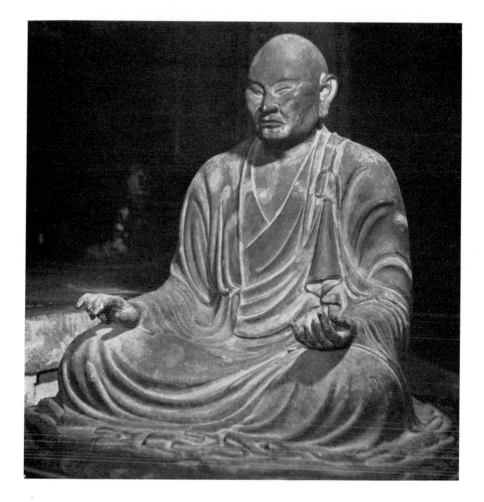

Sculpted portraits in the strict sense, reflecting the physical appearance of venerated monks, were made for commemorative purposes. There is a document relating the circumstances surrounding the commission of a portrait, now lost, of the Indian monk Bodhisena, known in Japan as Baramon Sōjō (the Brahmin monk), who had officiated at the ceremony of the consecration of the Great Buddha of Tōdai-ji in 749. This document elucidates the motivations behind the commission of portraits at that time. It states, "In order to make clear the meritorious service of this monk, there is nothing equal to the construction of a portrait and transmitting it to later generations. . . . Although his wisdom died with him, his merits will continue to exist along with his portrait."

The first and foremost example of true portrait sculpture is the hollow dry-lacquer statue of the monk Ganjin (pls. 5–6) enshrined in Tōshōdai-ji. A work of the late

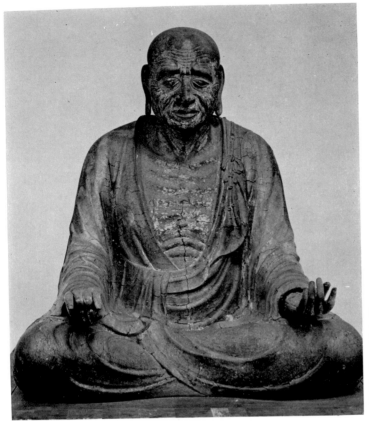

93. Gien. Painted wood. 90.9 cm. Early Heian. Oka-dera, Nara. (For detail see pl. 72.)

94. Dōsen. Painted clay. H. 88.2 cm. Probably made shortly after his death in 876. Yumedono, Hōryū-ji, Nara.

Tempyō period (711–81), dating around 763, it is a remarkably vivid portrayal, masterfully executed, with great feeling for and understanding of the character of the subject. He is shown seated quietly, placid and composed, with a slight smile playing around the corners of his mouth and eyes. The startlingly defined musculature of the nape of his neck, however, imparts a sense of the firm will concealed behind the affable countenance. Technically speaking, the characteristics of the dry-lacquer technique have been here admirably exploited, capturing accurately the most important features while avoiding excessive interest in details.

Only slightly later than the Ganjin portrait is another work of primary aesthetic importance, the hollow dry-lacquer portrait of the monk Gyōshin (pls. 91–92) in the Yumedono of Hōryū-ji. Gyōshin's personal history is unclear, but his portrait may have been enshrined in the Yumedono because of his efforts toward the reconstruction of the Eastern Precinct of Hōryū-ji, where that hall is located. Though as vivid as the Ganjin statue, Gyōshin's portrait shares little of its serenity and is instead somewhat fearsome, no doubt a reflection of his character. There is a sense of experimentation in the bold variations of the garment folds, unlike the slightly more linear treatment of the folds in the earlier figure.

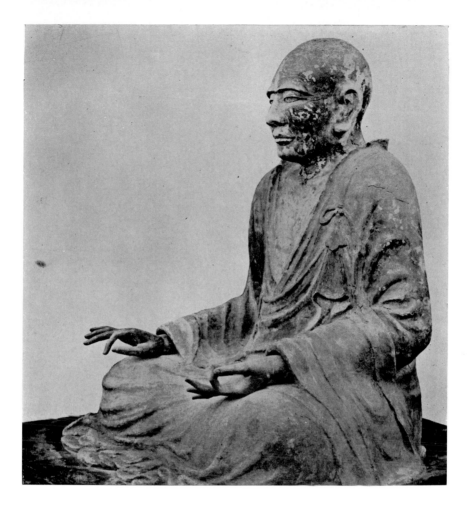

THE HEIAN PERIOD

The Heian period begins with the removal of the capital from Nara in 782, to be eventually established as Heian-kyō (modern Kyoto) in 794. Two tendencies are manifested in the sculpture of the first part of the Heian period and are reflected in the portraiture of that era: there are works still in the style of the Nara ateliers, and there are those exhibiting the characteristics of single-woodblock construction *(ichiboku-zukuri),* associated with the beginning of the Heian period.

Two Tendencies in Early Heian Sculpture

An example of the continuing Nara tradition is the statue of the Ritsu monk Dōsen (pl. 94) enshrined in the Yumedono of Hōryū-ji. The individualized countenance of this figure is marked by a naturalistic treatment, and the garment folds are strongly reminiscent of the preceding period. Not only is the portrait executed in the realistic mode prevalent in Nara times, but it is also made of unbaked clay, a medium characteristic of that period. There is no specific date attached to this work, but it is likely that it was made shortly after the subject's death in 876.

Another sculpture that can be said to reflect the style of the preceding period is the portrait of the monk Gien (pls. 72, 93) in the Oka-dera in the Asuka district in Nara.

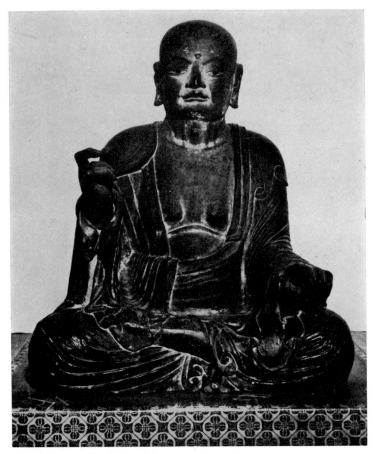

95. Gyōkyō. Single-woodblock construction.
H. 73.5 cm. Early Heian. Jinnō-ji, Kyoto.

Though considered by some scholars to be a work of the Nara period, it is executed
in a technique that began to be used toward the end of the early Heian period. It is
assembled using one large block for the upper part of the body, with separate pieces
for the hands, and smaller blocks joined together to form the lower half, with a lacquer
coating and a final covering of paint. Some scholars question the traditional identi-
fication of the work, for the earlobes are elongated and pierced as in representations
of the Buddha and other Buddhist deities. Rather than depict a specific personage, it
appears to reflect a more general arhat type. If the figure is in fact Gien, it would
have been produced long after his death in 728, and it would then have been likely
for the subject to have been given such saintly attributes.

The statue of Vimalakīrti (Yuima) in the Hokke-ji nunnery near Nara (pls. 55–
56) is also executed in the spirit of Nara-period realism. One of the largest and earliest
free-standing representations of this subject in East Asia, it is a wooden sculpture
with a dry-lacquer coating, naturalistically rendered, fresh and lively in its concep-
tion. Despite its spirited execution, the style seems to have hardened somewhat, indicat-
ing a date in the early Heian period.

The second tendency exhibited at this time reflects the style associated with single-
woodblock *(ichiboku)* construction, in which a statue is carved mainly from one large
100 block of wood. A work is considered to be done with the *ichiboku* technique as long as

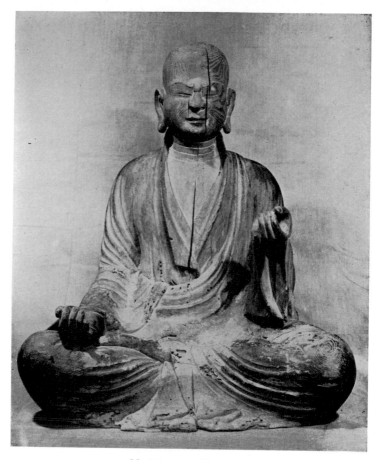

96. Mangan Shōnin. Single-woodblock construction (originally painted). H. 90 cm. Early Heian. Hakone Shrine, Kanagawa Prefecture.

the head and the trunk are carved from the same block of wood; the arms and knees may be carved separately. This technique came to be especially popular in the ninth and tenth centuries, and its distinctive traits are a massiveness reflecting the block from which it was hewn, a somewhat shallower carving of surface details, and a drapery technique known as *hompashiki* (alternating wave pattern), in which parallel rows of rounded folds alternate with linear folds in sharp relief.

The statue of Gyōkyō, a Ritsu monk who established the shrine of the war god Hachiman in Iwashimizu in 859, is executed in the *ichiboku* technique (pl. 95). The portrait is now in the Jinnō-ji in Kyoto. Its drapery is treated in the *hompashiki* style, and the whirl design on the garment is also characteristic of the period. The figure is not, however, individualized, and there appears a hair tuft *(ūrṇā)* on his forehead, one of the physical characteristics associated with the Buddha. It is therefore not to be regarded as a portrait in the strict sense but as a representation of the monk Gyōkyō that serves primarily as an object of worship.

A work in a similar vein is the statue of Mangan Shōnin in the Hakone Shrine in Kanagawa Prefecture (pl. 96). Mangan, the founder of this sanctuary, is believed to have died in 816. His portrait is a typical work of single-woodblock construction, and his garment exhibits the *hompashiki* pattern, suggesting a date not long after his death. The harsh facial expression can be considered portraitlike, but the three horizontal

101

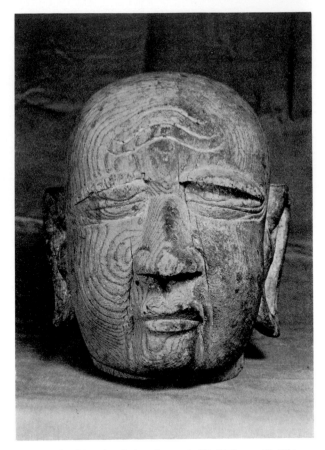

97. Head of Ennin. Painted wood. H. 22.2 cm. C. 864.
Risshaku-ji, Yamagata Prefecture.

lines carved into the neck and the elongated earlobes are attributes clearly belonging
to Buddhist images. In both the Mangan and the Gyōkyō portraits, which depict
personages who had lived in the comparatively recent past, the sculptors experiment-
ed with features associated with Buddhist deities. Religious reverence of the subjects,
rather than a wish to commemorate or cherish their memory, may have motivated
such experiments.

An unusual work of a portraitlike character is the small wooden head of Ennin
(pl. 97) found in his coffin in the Risshaku-ji in Yamagata Prefecture. The head shows
traces of paint, and its reverse has been planed flat, so that it was probably meant
to face upward in the coffin. The features are individualized and are carved with a
vigor indicative of an early Heian date. Ennin died in 864, and it is likely that the
portrait head dates from the same year.

Late Heian Sculpture

The late Heian or Fujiwara period is said to begin in the year 898, and to end in
1185 with the establishment of the Kamakura regime. These three centuries witnessed
an increasing trend toward Japanization in the arts, and mark the zenith of Japanese
aristocratic culture. In the field of sculpture there were significant developments.
Individual sculptors began to be recognized for their achievements and were granted

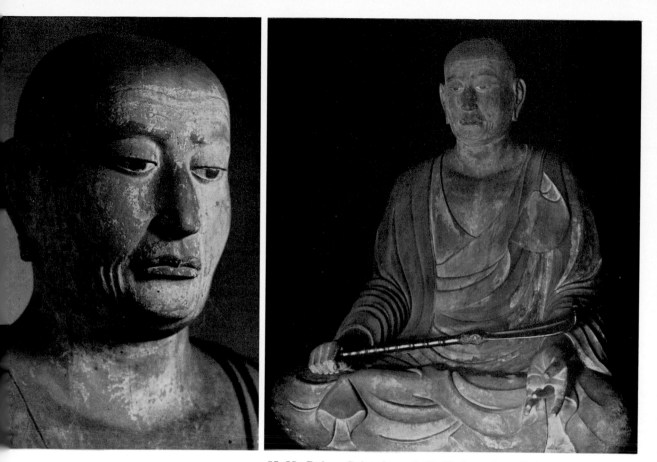

98–99. Rōben. Painted wood. H. 92. 4 cm. Late Heian. Tōdai-ji, Nara.

ecclesiastic titles, while large sculptural workshops centered on such prominent artists were established. An indigenous sculptural style developed. A technical innovation, joined-woodblock construction *(yosegi-zukuri)*, was introduced and gradually perfected during this period.

The general development of late Heian portrait sculpture can be traced in a series of representations of the Tendai monk Enchin. The so-called Okotsu (Bone Relic) Daishi statue in the Onjō-ji (pl. 74) is thought to have been made immediately after the monk's death in 891. It has not yet lost the massive, sturdy qualities of single-woodblock construction. The egglike shape of the monk's head perhaps reflects one of his actual physical characteristics, although the facial features themselves are hardly individualized. The garment folds form a bold and simple pattern, but their treatment reveals a certain hardening that will become increasingly apparent in later works.

The so-called Sannō-in Daishi (pl. 75), also in the Onjō-ji, generally resembles the Okotsu Daishi, but one can immediately notice disparities in the details: the head has become a distinctly more pointed oval, the figure as a whole has been given a fuller, more blocklike character, and the drapery has been arranged in shallower, more regular folds. The slightly more stylized quality of the work indicates a somewhat later date than that of the Okotsu Daishi.

103

Two later works based on the Onjō-ji statues preserve the general characteristics of the earlier works. The portrait in the Nyakuō-ji in Kyoto is modeled after the Okotsu Daishi. Though retaining even the same pattern of garment folds, it imparts a more polished quality. The figure of Enchin in the Shōgo-in in Kyoto (pl. 9) was carved by the Buddhist sculptor Ryōkai in 1143 in celebration of the two hundred fiftieth death anniversary of the venerated monk. As seen from the shape of the head and the features, it was based on the Sannō-in Daishi, but the eye sockets have been more clearly defined than those of the earlier work. The figure as a whole, however, is not quite as squat, and the drapery has been given a softer, more flowing treatment.

These four statues cover a span of two hundred fifty years. The limitations imposed by the need to retain portraitlike features and to adhere to certain conventions in depicting Enchin have restricted the extent to which the general trends in the development of sculpture might have otherwise affected these works. They all maintain a definite solidity, and the two Onjō-ji portraits and the Nyakuō-ji statue are executed in a technique closer to the *ichiboku* method of construction than to the *yosegi-zukuri* more typical of the late Heian period. However, there is undoubtedly a growing trend toward stylization and idealization and an increasing tendency to avoid strong or harsh expression.

One of the outstanding works of late Heian portraiture is the statue of the eighth-century monk Rōben (pls. 98–99), adviser to the emperor Shōmu and founder of Tōdai-ji, where his portrait is enshrined. The work, made around 1019, is executed in a technique still close to the *ichiboku* method, and its original coloring is largely intact even now because it was kept as a secret image and displayed only once a year. The figure as a whole is stately and imposing, and tending toward the hieratic. Though a realistic intent can be discerned in the figure, the work exhibits a stylized quality most apparent in the sharply defined and meticulously arranged drapery.

Two representations of Shōtoku Taishi are also indicative of the tendencies of Fujiwara sculpture. The so-called Seven-Year-Old Image (pl. 67) in the E-den (Painting Hall) of Hōryū-ji is known to have been carved by the Buddhist sculptor Enkai in 1069. This accomplished orthodox sculptor composed the figure in a smooth and broadly treated manner, imparting a general sense of full, rounded volume. Because of its imaginary character, there are no portraitlike, individual characterizations in the features. The statue of the prince regent Shōtoku dedicated in 1121 and enshrined in the Shōryō-in of the same temple (pl. 13) is not only stylized but also schematized. There is no sense of a living individual in this figure at all. Its countenance is hardly more lifelike than the drapery, which is arranged in neat and shallow unnaturalistic folds.

THE REALISM OF THE KAMAKURA PERIOD

The Kamakura period lasted almost two centuries, if we include within it the era of the Nambokuchō—from the fall of the Taira family in 1185, through the division of

the imperial government into the Northern and Southern courts *(nambokuchō)*, to the end of the fourteenth century, when the two courts were reunited. Unlike the emphasis on elegance and idealization prevalent in the art of the late Heian period, the Kamakura aesthetic stressed realism in the arts and sought to invest works of art with a vigorous naturalism more in keeping with the expansive spirit of the period itself. The technique of *yosegi-zukuri* continued to be used throughout the Kamakura period, and the use of inlaid crystal for the eyes *(gyokugan)* became a universal practice at the time.

The trend toward naturalism received its impetus from three major sources. In repairing and rebuilding works in the Nara area destroyed during the Gempei wars, sculptors became reacquainted with the realistic style and techniques found in the art of the Nara period. There was the newly revitalized Buddhism of the Kamakura period in the Jōdo, Shin, Ji, Nichiren, and Zen sects that aimed less toward the aristocracy, the traditional patrons of Buddhism, and more toward the warrior and plebeian classes, which encouraged more readily understandable symbols of the faith. Finally, the renewed Chinese artistic influences, coming from the trade and cultural centers of the Sung empire, brought new modes of popular Buddhist imagery as well as innovations in the art of painting.

The realistic spirit of the Kamakura period was highly conducive to the development of portraiture. Not only did the techniques necessary for naturalistic representation reach a remarkable level of sophistication at this time, but there also was a need for lifelike depictions of venerable monks in the new Buddhist sects that placed growing emphasis on the charismatic personalities of their founders and teachers.

Early Kamakura Works

By the beginning of the Kamakura period, the system of sculptural workshops established in late Heian times had developed into three major schools: the traditional and conservative In and En schools were centered in Kyoto; the Kei school was headquartered in the Kōfuku-ji in Nara, so that its sculptors were also known as *nanto busshi,* or sculptors of the southern capital. In the first few decades of the period, the Kei school, with its great masters Unkei and Kaikei, came to predominate and remained preeminent throughout the early Kamakura period. Unkei and Kaikei each developed a distinctive style of his own, originating trends that were to exert great influence for well over a century.

Statues of the Six Monks of the Hossō Sect (pls. 100–109) were carved by Kōkei, father of Unkei, in 1189 and are enshrined in Kōfuku-ji. These works were produced during the reconstruction undertaken in the Nara area after the Gempei wars and show the influence of Nara-period realistic sculpture. Certain elements in these figures indicate a style not yet fully formed, but their vigorous naturalism marks a distinct break from the elegant Fujiwara aesthetic and is a harbinger of the fully formed Kamakura realistic style.

105

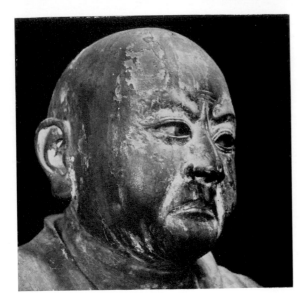

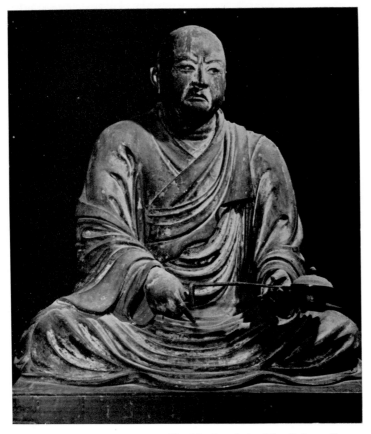

100–101. Zenshu, one of the Six Monks of the Hossō Sect. By
Kōkei. H. 83 cm. 1189. Kōfuku-ji, Nara.

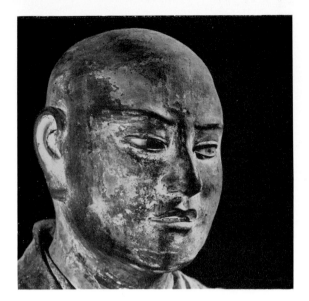

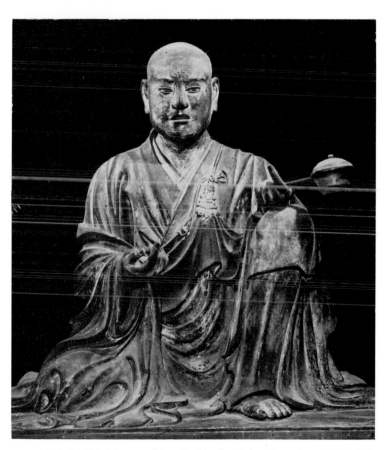

102–3. Shin'ei, one of the Six Monks of the Hossō Sect. By Kōkei.
Painted wood. H. 81.2 cm. 1189. Kōfuku-ji, Nara.

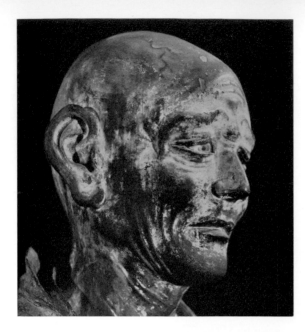

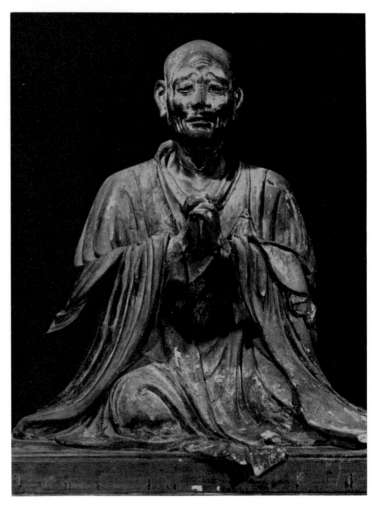

104–5. Gembō, one of the Six Monks of the Hossō Sect. By Kōkei.
Painted wood. H. 84.8 cm. 1189. Kōfuku-ji, Nara.

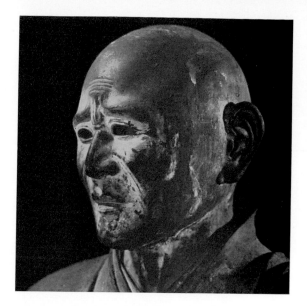

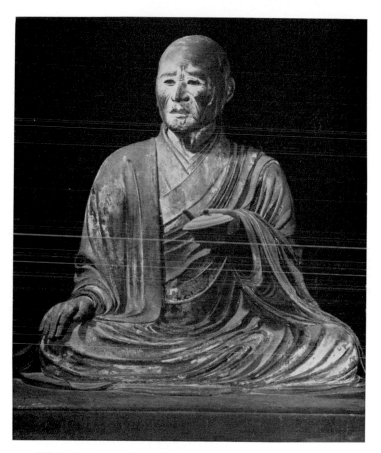

106–7. Jōtō, one of the Six Monks of the Hossō Sect. By Kōkei.
Painted wood. H. 73.3 cm. 1189. Kōfuku-ji, Nara.

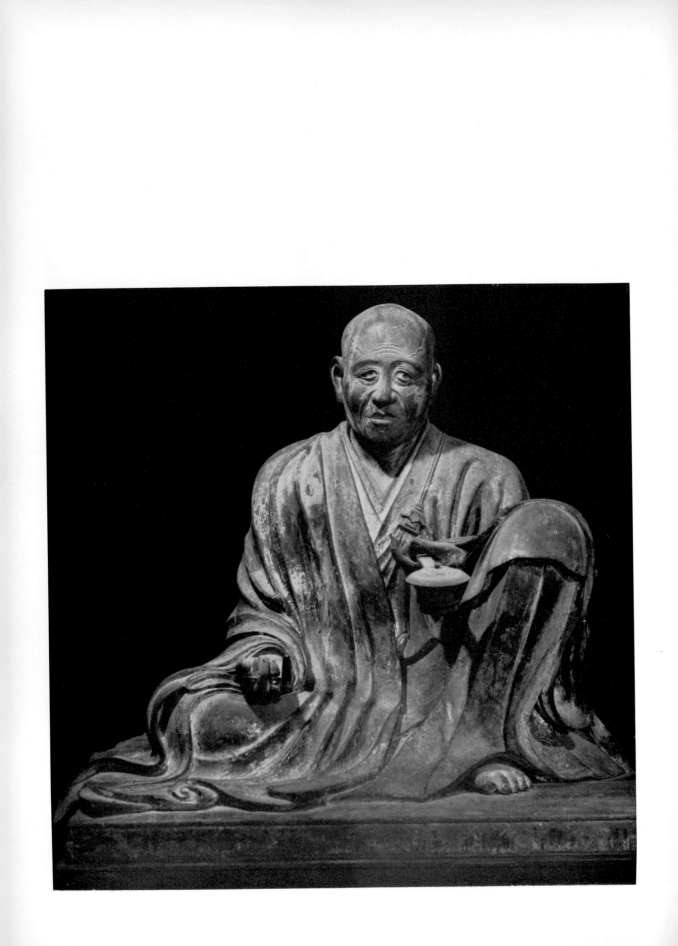

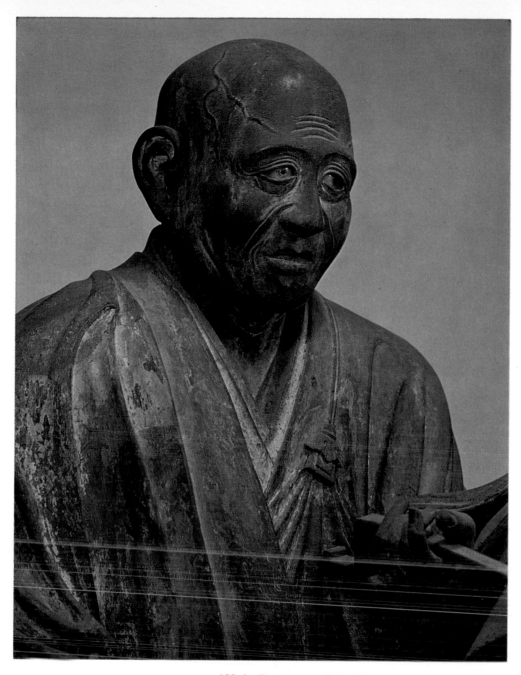

108–9. Gyōga, one of the Six Monks of the Hossō Sect.
By Kōkei. Detail. Painted wood. H. 74.8 cm. Kōfuku-ji,
Nara.

These six figures were carved by Kōkei, father of Unkei,
in 1189, during the reconstruction undertaken in the
Nara area after the Gempei wars, and show the influence
of Nara-period realistic sculpture. This set of figures is
extremely important in the history of Japanese sculpture,
for it marks a rejection of the elegant, aristocratic Fuji-
wara sensibility, and a turn toward naturalism, which,
in the hands of the succeeding Kei-school masters, was
to become the hallmark of the sculpture of the Kama-
kura period. (See also pls. 100–107.)

Another work that clearly shows Nara-period influence is the wooden statue of Vimalakīrti (Yuima) in Kōfuku-ji carved by the sculptor Jōkei in 1196 (pl. 57). Jōkei is sometimes identified as the second son of Unkei, but it is more likely that he was simply a disciple of Kōkei. Jōkei manages to assert his own artistic personality even in this school of accomplished masters, and his works indicate a knowledge of Sung sculpture as well as a familiarity with the Nara-period style. Even a cursory comparison of the Kōfuku-ji Vimalakīrti with the statue of the same subject in the Hokke-ji nunnery in Nara (pls. 55–56) reveals an affinity between the two. However, the differences, especially noticeable in the drapery, indicate the disparity in attitudes toward realism in the periods; one could not mistake the Kōfuku-ji statue for a Nara-period work. This work is also noteworthy for its lustrous Sung-like finish, an indication that Jōkei had begun to assimilate Chinese influences by 1196.

An important vehicle for the importation of Sung culture was the famous monk Shunjōbō Chōgen, who was responsible for the reconstruction of the Hall of the Great Buddha at Tōdai-ji. Chōgen had occasion to visit China three times and returned with knowledge of mainland art and architecture. There are two portraits of Chōgen noteworthy for the fact that they were carved during his lifetime and were self-commissioned. One is in the Shin Daibutsu-ji in Mie Prefecture and the other in the Amida-ji in Yamaguchi Prefecture. The practice of commissioning one's own image is unusual at this time, and it may be thought that Chōgen was influenced by Chinese usage.

The most outstanding portrait of Chōgen is enshrined in the Shunjō-dō of Tōdai-ji (pls. 73, 81) and can be thought to have been made shortly after his death in 1206. The figure is uncompromisingly realistic, without a trace of idealization. This is undoubtedly a portrait in the purest sense, imparting not only a sense of the particular individual but also a specific time in his life, and seeking to convey the particulars of his character. The work is quite unlike any of the others previously discussed, and a new sensibility, a fresh approach to the concept of portraiture, can be detected here. It is likely that the work was executed by a member of the Kei school, considering Chōgen's involvement with the rebuilding of Tōdai-ji and the association of the Kei school with the reconstruction activity in the Nara area.

The realistic technique in a slightly modified form was applied to imaginary portraits as well, resulting, for example, in such works as the Asaṅga (Mujaku, pls. 111–12) and Vasubandhu (Seshin, pls. 110, 113) statues carved by Unkei. These works are considered masterpieces of the Kamakura period. Unkei's oeuvre marks the zenith of the development of the sculpture of this period and determines many of the characteristics of the Kamakura realistic style. These two statues, dating from 1208, belong to the mature phase of Unkei's career and are indicative of a style fully assimilated and a technique completely understood.

Another set of imaginary portraits, the Ten Great Disciples of Śākyamuni in the Daihōon-ji (pls. 37, 44–52), was carved by Kaikei, whose manner is known as the An'ami style. Kaikei changed his name to An'amida Butsu in emulation of his patron

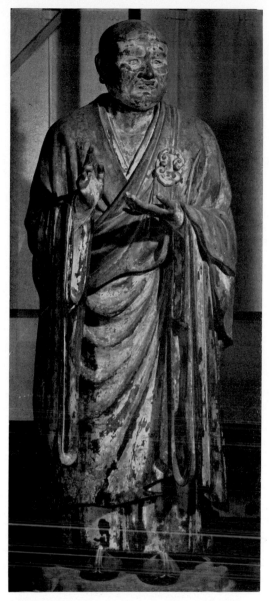

110. Vasubandhu (Seshin), by Unkei. Painted wood. H. 191.6 cm. 1208. Hokuen-dō, Kōfuku-ji, Nara.

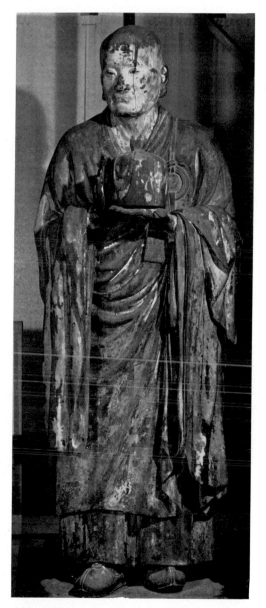

111. Asaṅga (Mujaku), by Unkei. Painted wood. H. 194. 7 cm. 1208. Hokuen-dō, Kōfuku-ji, Nara.

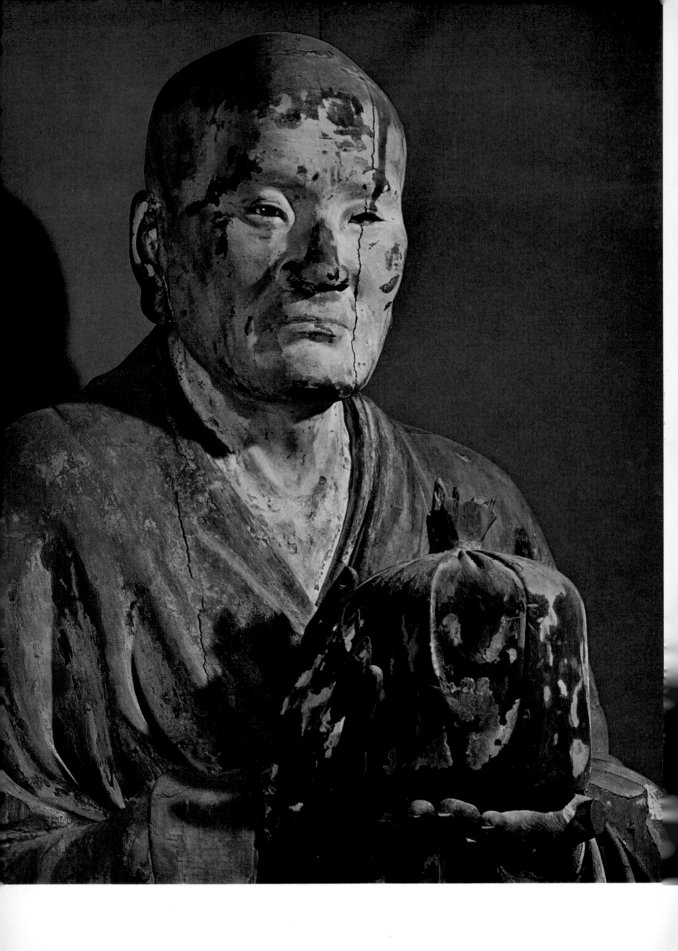

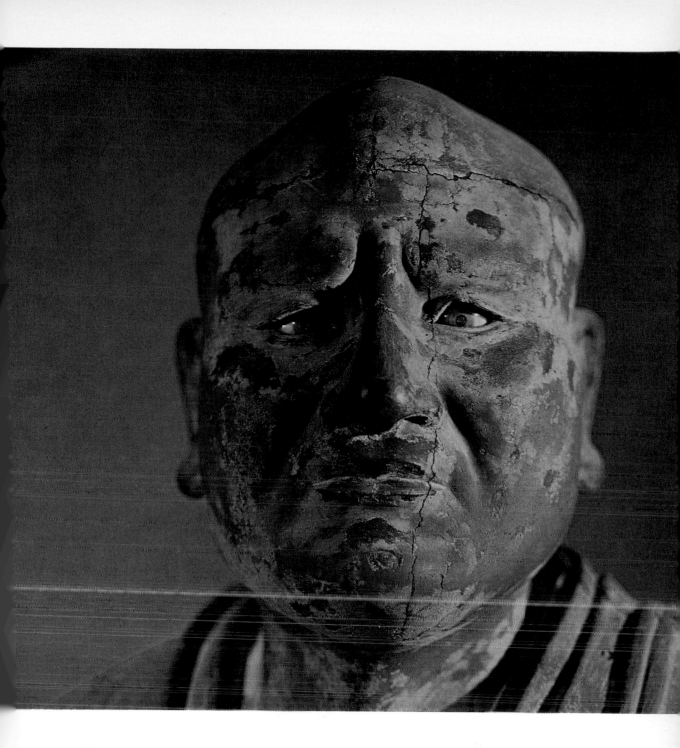

112. Asaṅga (Mujaku), by Unkei. Detail. Painted wood. H. 194.7 cm. 1208. Hokuen-dō, Kōfuku-ji, Nara.
Works of the mature phase of the career of the master Unkei, this creation and the portrait of Vasubandhu (Seshin) determine many of the characteristics of the Kamakura realistic style. They were produced during the great sculptural activity in the Nara area in the late twelfth and early thirteenth centuries.

113. Vasubandhu (Seshin), by Unkei. Detail. Painted wood. H. 191.6 cm. 1208. Hokuen-dō, Kōfuku-ji, Nara.
Paired with the statue of Asaṅga (Mujaku), this figure is universally acknowledged as one of the masterpieces of Japanese sculpture. Work on the pair was begun in 1208 by the master sculptor Unkei and his workshop. The artistic sensitivity and technical skill manifested in this figure reveal Unkei at his best.

Chōgen, whose pseudonym was Namu Amida Butsu. Kaikei's style is softer and more delicate than that of Unkei and strongly reflects Sung influence.

The portrait traditionally believed to be that of Taira no Kiyomori in the Rokuharamitsu-ji in Kyoto (pls. 116–17) depicts a seated monk holding a sutra scroll in his hands. Carved obviously by an accomplished sculptor in the realistic style, it manages to convey a feeling of movement in the figure enhanced by the flowing drapery.

The figure of Shan-tao (Zendō) in the Raigō-ji in Nara (pl. 34) is also an idealized figure executed in a realistic technique, portraying the founder of the Chinese Pure Land sect. Like the figure of Kiyomori, this statue conveys the image of a person engaged in an activity characteristic of his personality or achievements, for the monk is shown seated with his hands held in prayer, chanting a mantra that was once represented by six small figures of Amitābha emerging from the statue's mouth.

The best-known and most successful work in this idiom is the statue of Kūya in Rokuharamitsu-ji (pls. 76–77) carved by Kōshō. The exact date of the work is not known, but it was made before the year 1207, when Kōshō became a fully ordained monk. The work is executed in the realistic style, but a certain tentative quality in the carving is no doubt due to the fact that the sculptor had not yet reached artistic maturity. The manner in which the subject is depicted, as a full-length figure walking while chanting a mantra as if on a pilgrimage, is fresh and innovative, without any clear precedent in Japanese portrait sculpture. This method of depicting the individual through a descriptive, characteristic attitude is hardly a psychological portrayal of the subject but manages to convey his personality. Later representations of Kūya, such as those in the Sōgon-ji in Shiga Prefecture and the Jōdo-ji in Ehime Prefecture, are also treated in this manner.

A mature work by the sculptor Kōshō is the famous portrait of Kūkai (pl. 70) enshrined in the Miei-dō of Tō-ji. It was carved in the year 1233, and became the model for many later portraits of the monk. Executed almost four hundred years after Kūkai's death, the portrait is necessarily imaginary, based on a conventional form established in the Heian period, which may be seen, for example, in the paintings of the eight patriarchs of the Shingon sect in the five-storied pagoda of the Daigo-ji in Kyoto. The figure is nonetheless invested with strength and vigor and exhibits virtuoso technique in the highly complicated and magnificently executed drapery.

In Rokuharamitsu-ji is a statue of Kūkai carved by the Buddhist sculptor Chōkai, thought to be a disciple of Kaikei, during the Kenchō era (1249–56). It was modeled after the Tō-ji portrait of Kūkai (pl. 70), but the figure as a whole is considerably stiffer, and its carving is not as technically proficient as the earlier work.

The portrait of the Nara-period monk Gyōki in Tōshōdai-ji (pl. 69) is thought to have been made on the five-hundredth anniversary of his death, around 1249. The style of the work is consistent with such a date. The countenance, attitude, and drapery have been rendered realistically, but the overall treatment has hardened a bit, suggesting a date after the Kamakura realistic style had begun to decline.

The statue of Myōe Shōnin in the Kōzan-ji in Kyoto (pls. 114–15) was made sometime before 1253, when it is mentioned in a document. His handsome appearance is preserved in this portrait in the realistic style, and the top of his right ear, which he had cut off during his ascetic regimen, is missing. In this work, too, there is a definite hardening of the style, a loss of vigor apparent especially in the drapery, which would place the statue in the middle of the Kamakura period.

A pair of portraits depicting the sculptors Unkei and Tankei in the Rokuharamitsu-ji (pls. 118, 119) had originally been enshrined flanking a figure of Jizō, the main object of worship in the Jūrin-in of Bodai-ji, the Kei family temple built by Unkei. Both statues are treated in the realistic manner, but the portrait of Tankei appears to be of a later date than that of his father, Unkei, for the surfaces are more broadly rendered and details less meticulously carved in the Tankei statue.

New Developments in Late Kamakura Portraiture

Sculpture of the late Kamakura period, as discussed earlier, tended to exhibit an increasing stylization of forms and at times displayed instances of purely formal exaggeration. Though the quality of sculpture in general began to decline, there were a number of significant new developments in the realm of portraiture that helped to keep the quality of portrait sculpture at a high level.

One of the innovations in the portraiture of this period was the introduction of the formal, lay portrait. The three outstanding examples of this genre are the statue of Hōjō Tokiyori in the Kenchō-ji (pl. 90), the figure of Uesugi Shigefusa in the Meigetsu-in in Kanagawa Prefecture (pls. 88–89), and the so-called Minamoto no Yoritomo in the Tokyo National Museum (pl. 86). The statue of Tokiyori was made shortly after his death in 1263, and it is likely that the other two portraits were carved not long thereafter. These figures mark the first appearance in sculpture of the layman in court dress (though paintings of similar subjects can be seen in the early Kamakura period) and indicate a basic change in attitude whereby portraiture is no longer restricted to religious personages. As in the nise-e on which these portraits are based, the countenance is depicted realistically, but the figure and garment are schematized.

Another development in the field of portraiture in the late Kamakura period was the appearance of the Zen portrait (chinsō). This innovation was also based on a painting tradition, but unlike the lay portraits that grew out of a strictly Japanese style of painting, Zen portrait statues derive from Sung Chinese prototypes. The earliest chinsō sculpture is that of the monk Kakushin, later given the honorific title of Hottō Kokushi, in the Ankoku-ji in Hiroshima (pls. 83–84), carved in 1275, when the subject was sixty-eight years old. Kakushin had visited China, and it should be remembered that the first portraits made during the lifetime of the subject were representations of Shunjōbō Chōgen, who had also traveled to China. In the drapery of the Kakushin statue, however, can be seen many elements appearing in contemporary portraiture, so that the chinsō had not yet become an independent form.

117

114–15. Myōe Shōnin. Painted wood. H. 82.4 cm. Before
1253. Kōzan-ji, Kyoto.
Myōe was a Kamakura-period monk known for his
efforts to revive the Kegon sect as well as for cultivation
of the tea plant brought from China. Made sometime
before 1253, when it is first mentioned in a document,
this statue of Myōe Shōnin embodies his handsome
appearance through the realistic technique. Nonetheless,
one can sense a hardening of the style and a lack of
vigor in the drapery, factors that would place the por-
trait in the middle of the Kamakura period.

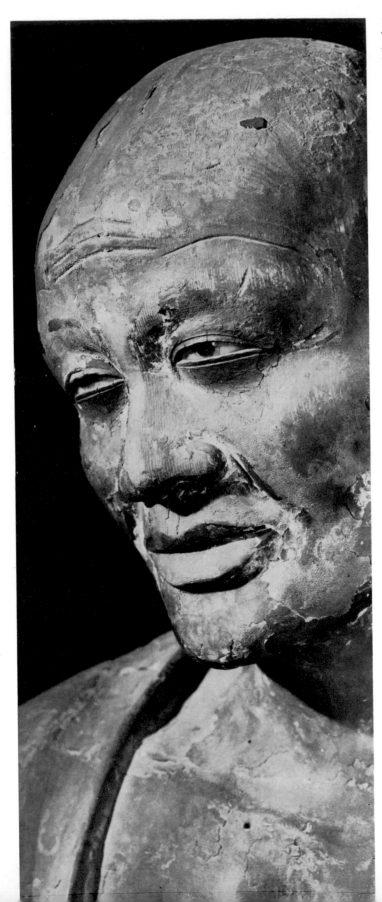

116–17. Portrait said to be of Taira no Kiyomori. Painted wood. H. 82.7 cm. Early Kamakura. Rokuharamitsu-ji, Kyoto.

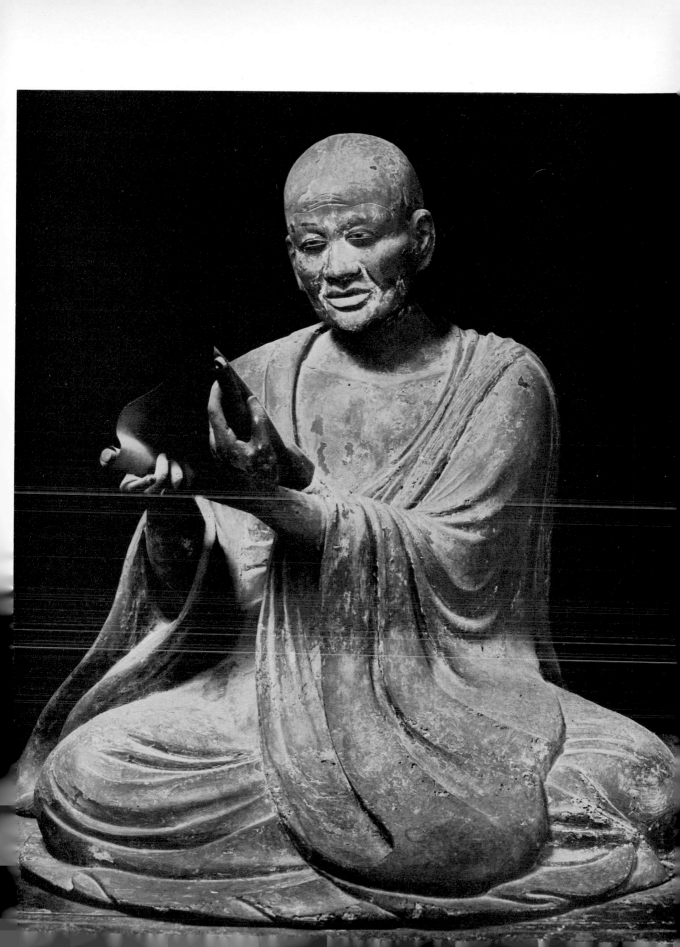

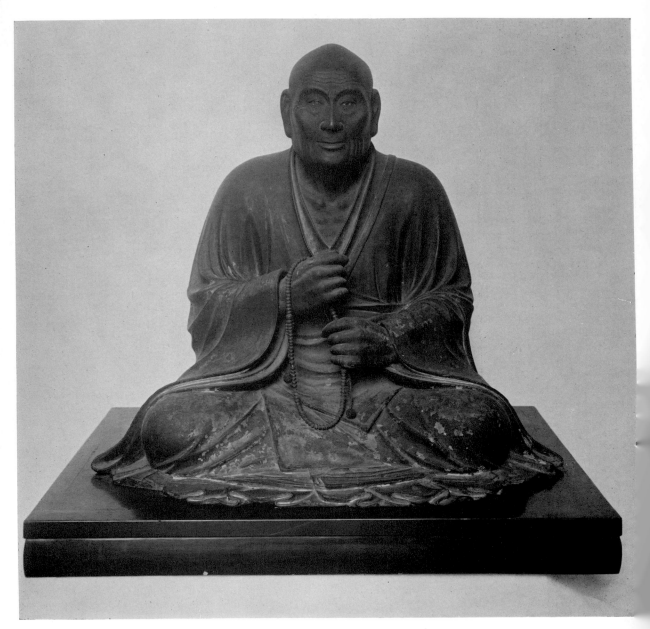

118. Unkei. Painted wood. H. 77.5 cm. Middle Kamakura. Rokuharamitsu-ji, Kyoto.

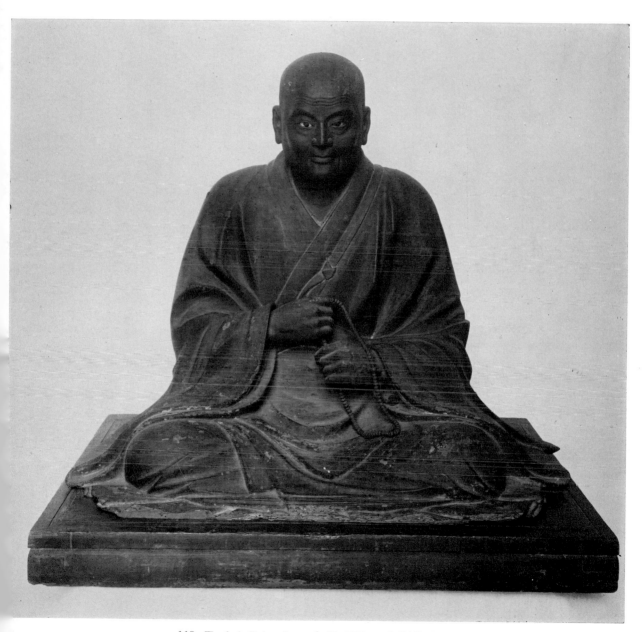

119. Tankei. Painted wood. H. 78.2 cm. Middle Kamakura. Rokuharamitsu-ji, Kyoto.

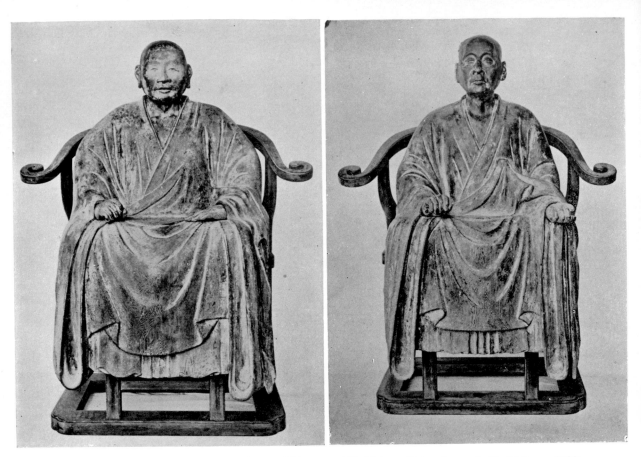

120. Hui-jen (Enin). Painted wood. H. 79.8 cm. 1329. Anraku-ji, Nagano Prefecture.

121. Yuisen. Painted wood. H. 74.2 cm. 1329. Anraku-ji, Nagano Prefecture.

In the *chinsō* of Bukkō Kokushi (Wu-hsiao Tsu-yüan) in the Engaku-ji (pl. 85) the naturalistic treatment of the countenance contrasts with the smooth, broadly treated garment, whose folds are not arranged in the flowing, realistic manner seen in the Kakushin portrait. This statue was most likely made soon after the subject's death in 1286.

The portrait of the Zen monk Daimei Kokushi in the Ryūgin-an of Tōfuku-ji in Kyoto (pl. 3) was produced soon after his death in 1291 and depicts the subject's features in a naturalistic manner, though not as successfully as the Bukkō Kokushi statue.

Very late in the Kamakura period, in 1329, two *chinsō* were produced and enshrined in the Anraku-ji in Nagano Prefecture (pls. 120, 121). Yuisen was a Japanese monk who had traveled to China, and the Chinese monk Hui-jen (Enin) returned to Japan with him. The two portraits are similar in form with the exception of the individualized faces. The drapery has become heavy and stylized, even more so than in any of the previously discussed *chinsō*, but the figures manage to retain a lifelike quality.

In portrait statues other than those of lay subjects and *chinsō*, the same general tendencies of increasing stylization and formal exaggeration can be traced. For ex-

124

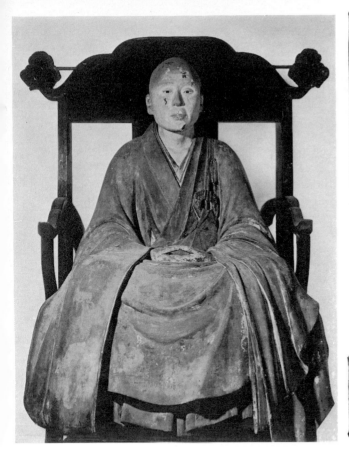

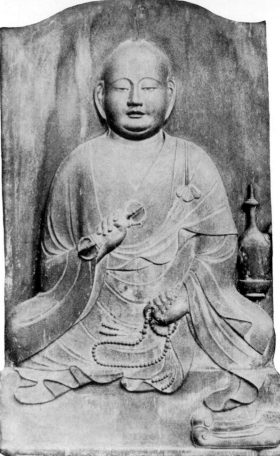

122. Musō Kokushi. Painted wood. H. 78.8 cm. Early Nambokuchō. Zuisen-ji, Kamakura.

123. Kūkai, by Jōki. Relief. Painted wood. Painted by Enjun. 1302. Jingo-ji, Kyoto.

ample, the statue of the tenth-century Tendai monk Ryōgen in the Manju-in in Kyoto (pls. 78–79) is known to have been carved in 1268, and the heavy, arbitrarily treated folds of the drapery are carved for the sake of the forms themselves rather than for the sake of naturalistic rendering. Since the portrait is imaginary and the monk himself was reputed to have been an exorciser of evil spirits, the figure is treated vigorously and with great freedom.

The portrait of Eizon in Saidai-ji (pls. 8, 82) is a *juzō,* carved by Zenshun in 1280, when the subject was seventy-nine years old. This impressive statue appears to have been produced with a realistic intent, but the sculptor takes obvious delight in the forms themselves, which becomes manifest in the elaborate and complicated rendering of the garment folds.

Nichiren's statue in the Hommon-ji in Tokyo (pl. 10) was commissioned by his disciples in 1288 on the sixth anniversary of his death. The figure imparts a benign and sympathetic quality, its surfaces unembellished by exaggerated forms. The drapery is treated in broad, smooth folds, and it should be kept in mind that this statue is shown in its undergarments, and when enshrined, is dressed in an actual surplice.

A technical innovation that occurs in the late Kamakura period is the production

of portraits in relief. The wooden plaque of Kūkai (pl. 123) in the Jingo-ji in Kyoto, carved by Jōki of the In school in 1302 and painted by Enjun, is one of the rare examples in this medium. The face has a rounded, sculptural quality, but the drapery is unmodulated and more painterly in conception. As a whole the relief is masterfully executed and leaves little feeling that the sculptor is working in an unfamiliar technique.

A statue that is useful in evaluating the changes that took place in the course of the Kamakura period is the portrait of Kūkai in the Gokuraku-bō of Gangō-ji in Nara (pls. 12, 20), dated 1325 and modeled after the Kōshō statue of Kūkai in Tō-ji (pl. 70). Almost a century separates the two works, and it is apparent that the resemblance between them is superficial. Although the fourteenth-century statue is in itself a noteworthy work, it is a far cry from the marvelously conceived and masterfully executed example of Kei-school realism seen in the Tō-ji portrait. The countenance of the later statue has a conventionalized quality about it, and the drapery exhibits a great deal of purely formal exaggeration. While the Tō-ji Kūkai communicates a certain spiritual presence, the Gokuraku-bō portrait emphasizes the carving of the surface forms to the extent that one ceases to perceive a sense of the person within.

Chinsō of the Nambokuchō

The era of the Northern and Southern courts *(nambokuchō)* is one of transition from the late Kamakura to the Muromachi period. Because the tendencies of the previous age continue with some added indications of the era to follow, a style that can be called typical of the fourteenth century does not emerge. The best works of the Nambokuchō are *chinsō,* for the Zen sect was one of the few religious orders still active in commissioning statuary.

The portrait of the most distinguished Zen monk of this period, Musō Kokushi (given name Soseki), which is enshrined in the Zuisen-ji in Kamakura, was carved shortly after his death in 1351 and is treated in the conventional *chinsō* manner, but the entire figure communicates a subdued and introspective quality (pl. 122). There is no exaggeration either in the features or in the garment; instead, the quietly composed countenance and the smooth, pliant drapery underscore the calm, contemplative nature of the work.

In contrast, the figure of the Zen monk Motsugai (pl. 124), made in 1370 by the Buddhist sculptor Chōsō and enshrined in the Fusai-ji in Tokyo, is highly stylized, with hardened forms that give it a heaviness emphasized by its generally blocklike shape. Not only is the drapery executed in broad planes, but the features also have a planar quality arising from the lack of modulation in the juxtaposed surfaces. This manner of carving the facial planes is a technique that can be also seen in the contemporary carving of masks for the newly popular Nō drama. Though the portrait of Musō Kokushi evokes a Kamakura-like sensibility, this statue of Motsugai is more indicative of the style of the Muromachi period.

126

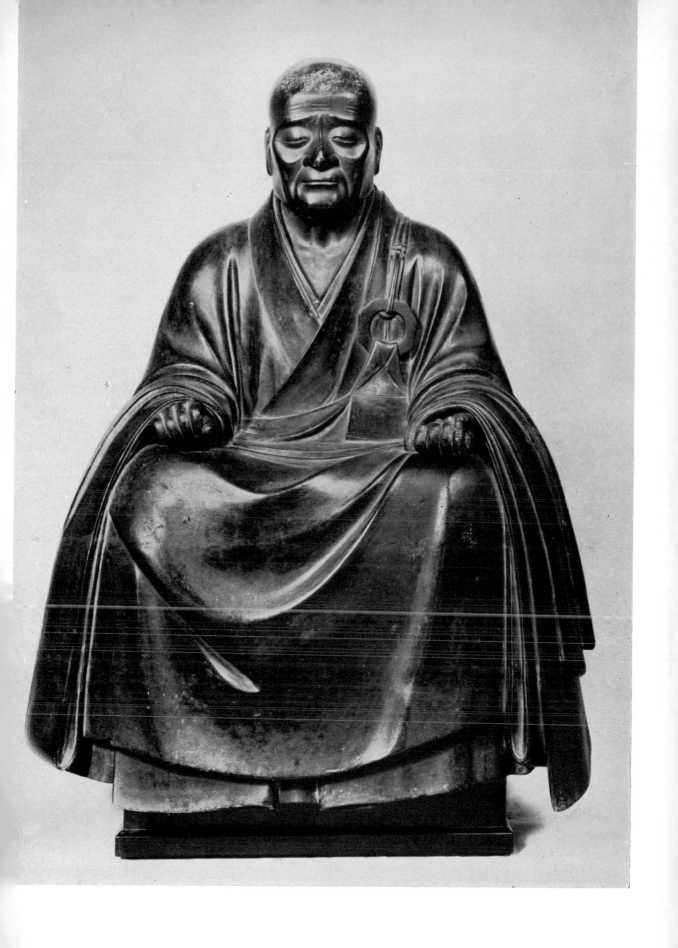

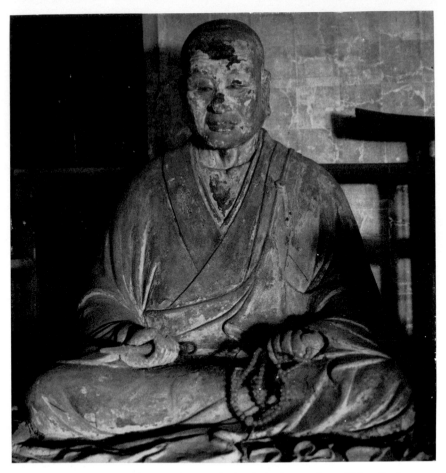

125. Jun'yū Naiku. Clay. Dedicated in 1398. Ishiyama-dera, Shiga Prefecture.

Increasing Stylization in the Muromachi and Edo Periods

With the reunification of the Northern and Southern courts in the late fourteenth century, uncontested power was centered in the Muromachi section of Kyoto under the Ashikaga shoguns. This period, called the Muromachi or Ashikaga, lasted until the fall of the ruling house in 1573. Though the field of painting was revitalized through Chinese techniques newly imported under the aegis of the Zen-oriented Ashikaga shoguns, the sculptural medium saw no such invigorating influences, and the Muromachi period is generally regarded by historians of Japanese sculpture as a time of decline when few works of aesthetic value were produced. The exceptions, however, are portrait sculptures.

A notable portrait that harks back to the style of the Kamakura period is the statue of the tenth-century monk Jun'yū Naiku (pl. 125), restorer of the Ishiyama-dera in Shiga Prefecture, where his image is now enshrined. It is known to have been dedicated in 1398 and is an example of the revival of the use of clay in portraiture.

The statue of Ippen Shōnin (pl. 126), founder of the Ji sect, is thought to have been made in 1420 by the Buddhist sculptor Kōshū. This full-length representation of the monk chanting the *nembutsu* as he goes on a pilgrimage is reminiscent of the Kamakura-period figure of Kūya (pls. 76–77) in its general conception. In style, however, this stiff and angular statue is far removed from the earlier lively and naturalistic

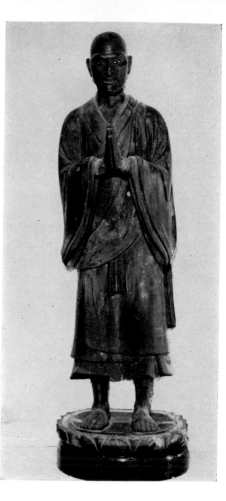

126. Ippen Shōnin. Attributed to Kō-
shū. Painted wood. 1420. Chōraku-ji,
Kyoto.

representation. The sharply carved, unmodulated cheekbones are executed in the
manner of Nō masks, a technique seen previously in the portrait of Motsugai (pl.
124).

An unusual statue is the Bodhidharma in the Daruma-dera in Nara (pl. 59), sculpted
in 1430 by Shūkei out of an older wooden image and painted by the monk Shūbun,
who was also a well-known master of ink painting. Though the depiction is necessarily
imaginary, the features are surprisingly expressive and rendered with great technical
proficiency.

The portrait of the Zen monk Ikkyū, forty-eighth abbot of the Daitoku-ji, enshrined
in the Shūon-an (pls. 32–33), is an object of great interest. It was carved immediately
after his death in 1481, and it appears that his own hair was implanted for the eye-
brows, mustache, and chin whiskers of the statue. The features themselves are frankly
rendered and individualized but have a raw quality that provides a sharp contrast
with the smooth, flat drapery.

In the set of portraits depicting the fifteen generations of Ashikaga shoguns in the
Tōji-in in Kyoto can be seen two noteworthy trends. This is the first large group of
portrait statues of lay subjects seen up to this point, and all of these figures are so
stylized and doll-like that it becomes difficult to designate them as sculpture. An
inscription on the representation of the tenth shogun, Yoshitane, states that that

129

particular figure was carved in 1542 by the Buddhist sculptors Kakutei and Kakukichi. The style and technique of the majority of the figures are so close to those of the Yoshitane image that it is likely that they were made at the same time and perhaps by the same hands.

The doll-like quality manifested in the group of the Ashikaga shoguns is a stylistic tendency that became prominent in the Edo period. The child image of Toyotomi Sutemaru (pl. 127) in the Rinka-in in Kyoto is also stylized and doll-like but is indicative of the quality that could be achieved even in this hardened style when it was applied to a child subject. It was carved during the short-lived Momoyama period (1573–99), when the two great warlords Oda Nobunaga and Toyotomi Hideyoshi reunited Japan after a century of constant warfare. Sutemaru was the first son of Hideyoshi, born to the warlord late in life. When the child died at the tender age of three, the grieving father commissioned this image to aid in his son's eventual attainment of Buddhahood. Unlike the figures of the shoguns dressed in stiff court garments, Sutemaru wears a child's robes that, though treated in a slightly more naturalistic manner, still have sleeves projecting out sharply to the sides in a manner similar to that seen in the group of shoguns.

The two figures of Toyotomi Hidetsugu and his mother, the nun Nisshū, produced in 1597 and 1601, respectively, in the Zenshō-ji in Kyoto, can no longer be called portrait sculptures and are more like manikins or dolls.

From the Edo period (1600–1867), when the capital was located in Edo, now modern Tokyo, there is little religious sculpture of which to speak, and that which exists is not of high quality. Figures such as the Ganjin in the Kaidan-in of Tōdai-ji, made in 1733 during the restoration of the Kaidan-in, copy older works, in this case the Tōshōdai-ji portrait, but the hardened technique and stylized forms leave the statue lifeless. Though images of secular subjects become widespread, these small representations of illustrious laymen commissioned by their families, such as the figure of Fujioka Chōbee in the Fukutoku-ji (inscribed 1813), are not portraits but devotional figurines placed near the Buddhist family altar.

By this time true portraiture was no longer in evidence. The momentum that had carried portrait sculpture through the preceding centuries was totally spent, and it was not until Japan encountered Western sculpture in the Meiji era (1868–1912) that the interest in true portraiture was revived and directed toward new horizons.

127. Toyotomi Sutemaru. Painted wood. H. 55.8 cm. Made shortly after his death in 1591. Rinka-in, Kyoto.

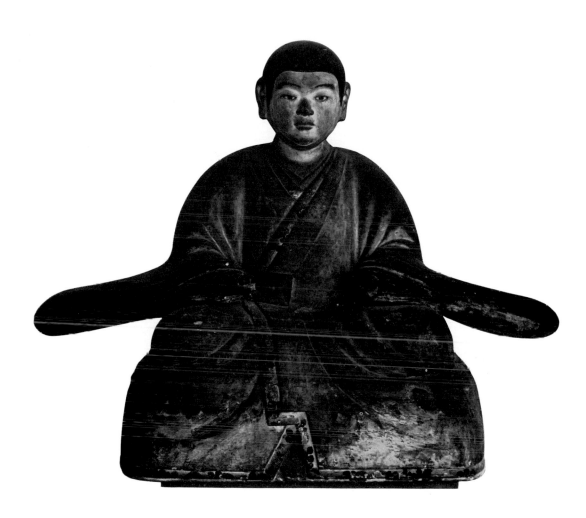

BIOGRAPHICAL SKETCHES
OF HISTORICAL PERSONAGES

BUKKŌ KOKUSHI *(1226–86)*. Bukkō Kokushi was the title given to the Chinese Zen monk Wu-hsiao Tsu-yüan (Mugaku Sogen), who founded the Engaku-ji in Kamakura. He came to Japan in 1279 at the invitation of Hōjō Tokimune, a Kamakura-period statesman, and was appointed abbot of the Kenchō-ji in Kamakura. Bukkō Kokushi was important in the history of Japanese Buddhism for having established a strong rapport between Zen and the warrior class.

CHŌGEN *(1120–1206)*. Known as Shunjōbō Chōgen, he assumed the name Namu Amida Butsu after he accepted the precepts of Jōdo (Pure Land) Buddhism. He became *dai kanjin* (chief promoter) of the restoration of the Tōdai-ji, and through his efforts the Daibutsu-den (Hall of the Great Buddha) of Tōdai-ji was successfully reconstructed in 1195. He visited China three times and helped introduce Sung styles of architecture and sculpture to Japan.

DAIMEI KOKUSHI *(d. 1291)*. Also known as Mukan Fumon, Daimei Kokushi was the first abbot of Nanzen-ji and third abbot of Tōfuku-ji. He studied under a Zen master in China for twelve years, and was a disciple of Shōichi Kokushi (Enji Ben'en), the first abbot of Tōfuku-ji.

DŌSEN *(d. 876)*. A Ritsu monk of the early Heian period, Dōsen was responsible for the second restoration of the Eastern Precinct of Hōryū-ji.

EIZON *(1201–90)*. The monk responsible for the Kamakura-period revival of the Ritsu sect, Eizon worked for the restoration of the Saidai-ji in Nara, was active in disseminating the Ritsu canon, and played an important role in revitalizing the faith in the Nara region. In 1262 he went to Kamakura at the invitation of the military rulers. He was awarded the posthumous title of Kōshō Bosatsu by the imperial court.

ENCHIN *(814–91)*. Posthumously named Chishō Daishi, Enchin was the fifth abbot of the Enryaku-ji, founder of the Onjō-ji and of the Jimon subsect of Tendai esoteric Buddhism. He was born in Sanuki Province (now Kagawa Prefecture) and was a distant relative of Kūkai. In 853 he went to China and studied T'ien-t'ai (Tendai) esoteric Buddhism and Siddham (a Sanskrit script). He returned to Japan after five years, having completed his compilation of T'ien-t'ai esoteric literature, with more than one thousand scrolls of Buddhist scripture and numerous ritual objects. Enchin wrote over one hundred volumes on Buddhism and contributed greatly to the development of Tendai esoterism.

ENNIN *(794–864)*. The Tendai monk Ennin was born in Shimotsuke Province (now Tochigi Prefecture) and was originally named Mibu. He studied under Tendai patriarch Saichō at Enryaku-ji, then left in 838 for China, where he studied esoteric Buddhism for nine years, returning in 847. He became the abbot of Enryaku-ji in 854. His *Nittō guhō junreikō-ki* (Record of a Pilgrimage in T'ang China in Search of the Buddhist Law) is an informative account of Sino-Japanese relations in the ninth century and contributes to the understanding of the

socioreligious atmosphere in China at the time. In 866 he was awarded the posthumous title of Jikaku Daishi by the imperial court.

EN NO OZUNU *(b. 634)*. Also known by the names En no Gyōja, En no Ubasoku, and (posthumously) Shimpen Daibosatsu, this Nara-period ascetic was the founder of *shugendō,* a Buddhist discipline that stressed the performance of religious austerities in the mountains. Born in Chihara in the Nara region, he began practicing religious austerities in the Ikoma and Kumano mountains and also underwent austerities in a cave on Mount Katsuragi for thirty years. In 699 he was slandered by a disciple and exiled to the island of Oshima. He was pardoned in 701 and returned to Nara, but soon left for Kyushu and was not heard from again.

GANJIN *(Chien-chen, 688–763)*. Ganjin established the Japanese Ritsu sect and founded the Tōshōdai-ji in Nara. He was originally from China, born in Yangchou. Leaving home at the age of fourteen, he studied the Lü (Ritsu or *vinaya;* emphasis on monastic discipline) and T'ien-t'ai (Tendai) doctrines. He was induced by the Japanese monks Eiei and Fushō, who went to China in 742, to transmit these doctrines to Japan. He attempted to cross the ocean five times and suffered many hardships in the process, losing his eyesight in an accident. He finally reached Tōdai-ji in 754, where he constructed the first ordination platform in Japan and performed the Buddhist ordination ceremony for the emperor Shōmu and the empress Kōmyō. He was invested with the highest ecclesiastical rank, that of *daisōjō.*

GIEN *(d. 728)*. A Hossō monk of the Nara period, Gien founded the Oka-dera in Nara, a temple converted from the Okamoto Palace donated by the imperial court. He was the teacher of such important Nara-period monks as Gyōki, Rōben, and Dōkyō.

GYŌKI *(670–749)*. Born in Izumi Province (now Osaka Prefecture), Gyōki entered Yakushi-ji and there studied yoga and the *yogācāra* doctrine of consciousness-only. He traveled widely, building temples and converting the masses. He also constructed ponds, dikes, and bridges, distinguishing himself in social welfare activities. Gyōki became the spiritual adviser to Emperor Shōmu and, for his assistance in the construction of the Great Buddha of Tōdai-ji, was later granted the title of *daisōjō,* the highest ecclesiastical rank. When he died in 749, he was among the most celebrated of the monks of the Nara period.

GYŌKYŌ. A ninth-century monk of the Daian-ji, Nara, Gyōkyō worshiped the Shintō war god Hachiman. He built a small Shintō shrine at Otoko-yama near Kyoto after he had had a divine revelation in the year 859 and, with imperial permission, modeled that shrine after Usa Hachiman Shrine.

GYŌSHIN *(d. 750)*. This early Nara-period monk greatly revered Shōtoku Taishi, and became abbot of the Hōryū-ji. For his service in lecturing to the empress Kōken on the *Lotus Sutra,* he was awarded an estate in Harima Province (now Hyōgo Prefecture), the income of which Gyōshin used to institute the *shōryō-e,* a ritual commemorating Shōtoku Taishi. He sought to reconstruct Hōryū-ji, which had fallen into disrepair, and is thought to have been responsible for erecting the buildings in the Eastern Precinct.

HŌJŌ TOKIYORI *(1227–63)*. The Kamakura-period statesman Tokiyori was the grandson of the *shikken* (regent to the shogun) Hōjō Yasutoki. He himself was appointed *shikken* in

1246 and governor of Sagami Province (now Kanagawa Prefecture) in 1249. In 1256 he took the tonsure and adopted the Buddhist name Dōsū. Besides being a statesman and strategist, he was an ardent follower of Zen Buddhism and invited the Chinese monk Lan-ch'i (Rankei) to Japan, whereupon he built the Kenchō-ji for the Zen master.

HOTTŌ KOKUSHI *(1207–98)*. Also known as Kakushin and Shinchi, Hottō Kokushi went to Sung China in the mid-thirteenth century, and received a certificate of advanced Zen studies from the monk Fo-yen. After returning to Japan, he founded the Kōkoku-ji in Kii Province (now Wakayama Prefecture), and became the first abbot of the Myōkō-ji, a villa converted into a temple by the courtier Fujiwara Morotsugu in 1285.

IKKYŪ *(1394–1481)*. Believed to have been of imperial descent, the Muromachi-period monk Ikkyū revolted against what he perceived as the absurdities of aristocratic and ecclesiastic privilege and position. He was raised in a temple, where he learned the basic concepts of Buddhism and was instructed in literature and science as well. His devotion to Zen arose from a purely personal experience, and he remained an ardent, if eccentric, follower of the sect throughout his career. The last seven years of his life were spent as the abbot of the Daitoku-ji in Kyoto.

IPPEN *(1239–89)*. His posthumous name was Enshō Daishi, and he is known as the founder of the Ji sect. Born in Iyo Province (now Ehime Prefecture), he entered Keikyō-ji at the age of six. He studied on Mount Hiei under the monk Jigen, and later became a disciple of Shōtatsu, a monk of the Seizen school of the Jōdo sect in Kyushu. He became a devout Jōdo Buddhist and embarked on a missionary journey throughout Japan. In 1276 he changed his name to Ippen after receiving divine inspiration. Because of his peripatetic activities, he came to be called Yugyō Shōnin (the Wandering Sage); he was also called Sute Hijiri (the Hermit).

JUN'YŪ NAIKU. A tenth-century monk who restored Ishiyama-dera in Ōmi Province (now Shiga Prefecture). Born to the Sugawara clan in Kyoto, he was ordained at the Kaidan-in of Tōdai-ji.

KŪKAI *(774–835)*. Also known by his posthumous title, Kōbō Daishi, Kūkai was the founder of the Shingon sect. He was born in Sanuki Province (now Kagawa Prefecture), and went to Nara to begin his studies of Chinese classics, history, literature, and Buddhist scripture. In 791 he wrote the *Rōko shiiki* (also *Sangō shiiki),* in which he compared the relative merits of Confucianism, Taoism, and Buddhism. He subsequently made plans to travel to China, and stayed there from 804 to 806, and was initiated there into the doctrines and rituals of esoteric Buddhism. When he returned to Japan, he brought with him many esoteric sutra texts, ritual manuals, Buddhist images, mandalas, and altar implements, and worked for the spread of the Shingon sect of esoteric Buddhism. In 816 he established the Kongōbu-ji on Mount Kōya. He died in 835, renowned for his accomplishments in calligraphy, education, and social welfare, as well as for his religious contributions.

KŪYA *(903–72)*. From the time he was a youth, Kūya, whose given name was Kōshō, traveled through a number of provinces while performing religious austerities. In 938 he went to live in Kyoto, where he walked through the streets continually chanting the *nembutsu* in order to convert the common people to the *nembutsu* faith. People of the time were

135

familiar with him and called him Ichi no Hijiri (Saint of the Market Place).

MANGAN *(d. 816)*. Mangan was the Buddhist monk who founded Hakone Shrine. He was a peripatetic holy man who traveled through the provinces, secluding himself on sacred mountains, where he is said to have experienced divine revelations that instructed him to build Buddhist temples and *jingū-ji* (Buddhist temples within Shintō shrines) in specific locations. The *jingū-ji* of the Tado and Kashima shrines were established by Mangan.

MOTSUGAI *(d. 1351)*. A Zen monk of the Rinzai sect, Motsugai studied under Nampo Jōmyō, a Chinese Zen master, and became his successor. He traveled in China from 1320 to 1329, where he visited the major Zen temples. At the behest of Hōjō Munetoki, he became the thirty-seventh abbot of the Kenchō-ji. He also founded Seitoku-ji and the Fusai-ji in Tokyo.

MUSŌ KOKUSHI *(1275–1351)*. Called Soseki, this famous monk of the Nambokuchō period was the spiritual adviser to the shogun Ashikaga Takauji, who entrusted him with the Tenryū-ji, a temple he erected on the western edge of Kyoto in 1339. Born in Ise, Musō Kokushi studied the sutras and Tantric rites before he was given the seal of Zen enlightenment by his master, Bukkoku Kokushi Kennichi. After becoming abbot of Tenryū-ji, Musō became a central figure in the religious activity of the capital. He also encouraged the shogun to reopen trade relations with China and advised him in establishing a system of Zen temples in sixty-six locations throughout the country.

MYŌE SHŌNIN *(1173–1232)*. This was an honorary title given to Kōben, a monk at the Kōzan-ji in Kyoto, who was to a large extent responsible for the revival of the Kegon sect during the Kamakura period. A member of the Taira family from Kii Province (now Wakayama Prefecture), he entered religious life at an early age. A strict observer of religious regulations, he placed a greater emphasis on moral rectitude than on the study of texts. He is also known to have planted the seeds of the tea plant brought back to Japan by Eisai from China.

NICHIREN *(1222–82)*. The founder of the sect that bears his name, Nichiren was of humble origins, the son of a fisherman in Awa Province (now Chiba Prefecture). He studied the teachings of Jōdo (Pure Land) at Kōmyō-ji in Kamakura and other doctrines at Nara, Mount Hiei, and Mount Kōya, after which he returned to the Seichō-ji in his native village of Awa and founded his own sect. His teachings were based on the *Lotus Sutra,* and he maintained that salvation could be attained through the recitation of the mantra *Namu-myōhō-renge-kyō* (Hail to the sutra of the lotus of the wonderful law). When he announced to the Kamakura warlords that if they failed to believe in the *Lotus Sutra* the country would be endangered, he was exiled to Izu, then further exiled to Sado. He was pardoned in 1274 and spent the remainder of his life in quiet seclusion.

RŌBEN *(689–773)*. Originally a Hossō monk taught by Gien, Rōben later devoted himself to Kegon Buddhism. He worked for the establishment of the Tōdai-ji and was promoted to the high ecclesiastical rank of *sōjō* in 773.

RYŌGEN *(912–85)*. Also called Jie Daishi, Ryōgen was born in Omi Province (now Shiga Prefecture). He studied with Risen and Son'i on Mount Hiei, and later became the eighteenth abbot of Enryaku-ji and attained the highest ecclesiastical rank of *daisōjō*. He is known to have begun a revival of the Tendai sect. He was believed to have had the power to exorcise

evil spirits and was popularly thought to be the reincarnation of a divine being.

SENGAN NAIKU *(d. 983)*. A scholar-monk of the Tendai sect, Sengan Naiku was particularly devoted to the Jōdo (Pure Land) creed and worked to convert others to that doctrine.

SHAN-TAO *(Zendō, 613–81)*. Known as the founder of the Chinese Pure Land sect, Shan-tao was from Su-chou in Anhui Province. He left home to become the disciple of the monk Ming Sheng. In his travels, he met Tao-ch'o, who taught him awareness of the nature of rebirth in the Pure Land. Shan-tao went on to explain the Pure Land to others according to the teachings of Tao-ch'o, copied a large number of Amitābha sutras, and painted representations of the Pure Land.

UESUGI SHIGEFUSA. A member of the famous daimyo family descended from Fujiwara no Yoshikado, he assumed the family name Uesugi from his hereditary domain in Tamba Province (now Hyōgo Prefecture), Uesugi no Shō, after having followed the imperial prince Munetake to Kamakura in 1252. He is known to have patronized the Zenkō-ji, with which the monastery of the Meigetsu-in (where his famous portrait is located) is affiliated.

GLOSSARY

Amitābha (Sk; J: Amida): The Buddha of eternal light and life. He is associated with the west, the location of his paradise (Sukhāvatī, the Western Pure Land), where he welcomes to unbounded happiness all those who call upon his name. While Amitābha's paradise is theoretically but a stage on the way to the ultimate goal of nirvana, it is popularly believed that it is the final goal of those who invoke the name of Amitābha (*Namu amida butsu,* "I put my faith in Amitābha Buddha"). The Pure Land (Jōdo) sect is especially devoted to this cult, and through this sect Amitābha became even more popular than the historical Buddha.

arhat (Sk; J: *rakan*): The saint or perfect man of Hīnayāna Buddhism. The term refers especially to the 16, 18 or 500 famous disciples of the historical Buddha.

Avalokiteśvara (Sk; J: Kannon): The bodhisattva of mercy. He is described in Buddhist texts as having thirty-three different forms and as being an attendant of the Buddha Amitābha. He is usually represented with a small image of Amitābha in his crown. The identification of Avalokiteśvara as a female is a very late development of Buddhism, not only in Japan but also in China, and is a product of popular Buddhism rather than a development arising from the Buddhist canon. Avalokiteśvara has the power to transform himself into any form, human or animal, for the sake of the salvation of sentient beings. Thus the female form would be one of the myriad possible manifestations of this deity who has transcended the level where beings are sexually differentiated.

bodhisattva (Sk; J: *bosatsu*): An enlightened demigod or saint who has vowed to post- pone his own Buddhahood until all sentient beings have attained salvation. The concept of the bodhisattva is one of the characteristic features of Mahāyāna Buddhism. In art, the bodhisattva is depicted wearing the costume and ornaments of an Indian prince.

chinsō (J): A formal sculpted or painted portrait of a Zen master. The form originated in China, where painted portraits were traditionally given by a Ch'an (Zen) master to his close disciples in recognition of their religious attainment and as evidence of their acceptance in his line. This practice was transmitted to Japan with the introduction of the sect in the late twelfth century.

Cintāmaṇi-cakra Avalokiteśvara (Sk; J: Nyoirin Kannon): One of the forms of the Bodhisattva Avalokiteśvara who saves all sentient beings with the gem of satisfaction (Sk: *cintāmaṇi;* J: *nyoi-shu*) and the wheel of the law (Sk: *dharma-cakra;* J: *hōrin*). The two-armed form is seated in European style (with both legs pendent), conveying an active sense, while the six-armed form is shown in the pose of royal ease, which indicates that the deity inhabits the mundane world.

dhāraṇī (Sk; J: *darani*): Spoken mystic formulas that "seal" the Buddhist ritual. In chapter 21 of the *Lotus Sutra,* the Buddha is quoted as having said that "by these talismanic words being pronounced out of compassion for creatures, the common weal of creatures is promoted; their guard, defense, and protection is secured." *Dhāraṇī* were highly developed in esoteric Buddhism. The *dhāraṇī* themselves are short texts or simply a group of mystic syllables that serve as supports for meditation.

dhyāna (Sk): Meditation, thought, reflection—profound and abstract religious contemplation. *Dhyāna* was an integral part of Buddhist discipline in both Hīnayāna and Mahāyāna Buddhism, but the practice of *dhyāna* became the basis of a separate school of Buddhism for the first time in China (Ch: Ch'an; J: Zen); this new sect stressed intuitive enlightenment and rejected scriptural and ecclesiastic authority.

eidō (J): Literally, "image hall," but used specifically to designate, within a temple complex, the portrait hall in which the portrait of the founder of the temple is enshrined. Its honorific form, *mieidō,* is used for portrait halls that enshrine representations of particularly venerable personages, and is the proper name (written "Miei-dō") for the portrait hall within the Tō-ji complex in Kyoto that houses the portrait of Kūkai, founder of Tō-ji and of the Shingon sect.

esoteric Buddhism (J: *mikkyō*): A late development of Mahāyāna Buddhism whereby mysteries are transmitted orally from master to disciple. It was a religion for the initiated rather than for the public. Unlike the doctrines of the historical Buddha Śākyamuni, which were spoken with the limitations of the audience in mind, the esoteric teachings were voiced by the cosmic Buddha Vairocana (J: Roshana) for his own enjoyment. *See also* Shingon; Tendai.

fly whisk (Sk: *cāmara*; J: *hossu*): In Buddhism the fly whisk symbolizes obedience to the Buddhist Law and the principle of "not hurting." It is made from the tail of a deer, or, more specifically, from the tail of the lead stag of a herd of deer, and therefore symbolizes leadership. The fly whisk is often carried by Buddhist dignitaries to symbolize the spiritual leadership they exercise over their disciples.

gorintō (J): In Shingon Buddhism, the *gorintō* or five-storied stupa symbolizes the Buddha Vairocana (Dainichi), who is the supreme divinity who underlies all things and manifests himself in the five elements of the world and in unrepresentable consciousness. Unlike the reliquary stupa, the five-storied stupa emphasizes the esoteric concept of the duality/nonduality of Knowledge and Principle.

hondō (J): The main hall of a temple where the principal object of worship is installed. Formerly called *kondō* ("golden hall").

ichiboku-zukuri (J): A method of wood sculpture in which a statue is carved mainly from a single block of wood. A statue was considered to be *ichiboku* even if the projecting limbs were carved separately, as long as the head and body formed a single block. Japanese wooden sculpture from the seventh through the eleventh centuries was largely executed in the *ichiboku* technique.

Ji sect (J: *ji-shū*): Sect organized by the followers of Ippen, who popularized devotion to Amitābha in Japan. *Ji* (time) signified the daily "six hour invocation of the *nembutsu*." The "six hours" indicated the divisions of one day according to the old Japanese reckoning, thus actually refers to 24 hours a day, so that the term *ji* stood for the perpetual invocation of the name of Amitābha.

Jōdo sect (J: *jōdo-shū*): The sect associated with the Buddha Amitābha whose Western Paradise or Pure Land *(jōdo)* was accessible to all who called upon his name with single-minded and whole-hearted devotion. Amitābha worship originated in the Mahāyāna Buddhism of Northern India and Central Asia and was tremendously popular in China before its transmission to Japan, where it became widely accepted during the Heian period.

juzō (J): A portrait or likeness of an individual produced during the subject's lifetime. The distinction is made since the vast majority of Japanese portraits are posthumous.

kaizandō (J): Literally, "founder's hall." The term can refer to the founder of either a temple or a sect.

Kegon sect (J: *kegon-shū*; Ch: *hua-yen-tsung*): 139

One of the principal Buddhist sects transmitted from China to Japan during the Nara period. The sect emphasized the concept of a cosmological harmony governed by the Buddha Vairocana (J: Roshana) who sits on a lotus throne of a thousand petals, each of which represents a universe. Within the great harmony all beings are related and their aim is to attain a fundamental communion with the cosmic Buddha. Shingon had originated in China as the esoteric teachings of the Kegon school.

kōdō (J): The lecture hall in a Buddhist temple complex.

kondō (J): Literally, "golden hall." The hall housing the main object of worship and other Buddhist images. With the pagoda (Sk: *stūpa*), one of the two chief elements in a Buddhist temple complex.

Kongōkai mandala (J: *kongōkai mandara;* Sk: *vajradhātu maṇḍala*): The mandala of the Diamond World. In Shingon practice a schematic representation of the cosmos in its dynamic aspect. The Buddha Vairocana is shown in contemplation in the center and is surrounded by other Buddhist deities and sacred implements. In Japan this mandala is placed to the west and represents wisdom or knowledge as derived from the underlying principle. It forms a pair with the Taizōkai mandala *(garbhadhātu maṇḍala);* neither exists without the presence of the other.

Komponchūdō (J): Literally, "Original Main Hall." Designates the most important building at Enryaku-ji, the Tendai headquarters on Mount Hiei outside Kyoto.

Kṣitigarbha (Sk; J: Jizō): A bodhisattva who is guardian of the earth and savior. He is depicted in monk's garb carrying a staff with six rings. He is given power over all the hells and is devoted to the salvation of all creatures between the nirvana of the historical Buddha Śākyamuni and the advent of the future Buddha Maitreya.

Mahāyāna (Sk): Literally, "Greater Vehicle." One of two fundamental divisions of Buddhism, the other being Hīnayāna (Lesser Vehicle). Offering salvation as accessible to all, its distinguishing doctrines are 1) the compassion of the bodhisattvas who have vowed to deny final nirvana for themselves until all other sentient beings have been saved through their efforts, 2) salvation by faith in, or invocation of, the Buddhas or bodhisattvas, and 3) paradise as a nirvana of bliss in the company of Buddhas, bodhisattvas, saints, and devout believers. Mahāyāna Buddhism is prevalent in Tibet, Mongolia, China, Korea, and Japan.

mandala (Sk: *maṇḍala;* J: *mandara*): A geometric disposition of symbolic attributes, seed syllables, or images that is endowed with magic power. It is the point of departure for a system of meditation whose purpose is to attain mystic union with the cosmic Buddha Vairocana. The best-known form of mandala is the one which is permanently depicted on paper or cloth and which serves as the object of successive meditations. Mandalas are an integral part of esoteric Buddhism.

Maitreya (Sk; J: Miroku): The Buddha of the future, residing in the Tuṣita heaven, who is to come to earth after 4,000 heavenly years (584 million earthly years) after the realization of nirvana by the historical Buddha Śākyamuni.

mantra (Sk; J: *shingon*): A sequence of mystic syllables, often without literal meaning, that occurs at the beginning, middle, or end of *dhāraṇī* (magical prayer formula). The mantra is supposed to produce a certain state of consciousness within the reciter through vibrations produced by the resonance of the mantric syllables within the body. The mantra OM contains in itself all the others (a,u,m, plus the dot [*bindu*] that marks nasal resonance). The use of the mantra was highly developed in esoteric Buddhism.

Nichiren sect (J: *nichiren-shū*): Sect founded by Nichiren (1222–82), for whom the *Lotus Sutra* was the key to salvation as the

final and supreme teaching of the historical Buddha Śākyamuni. The *Lotus Sutra* upholds the doctrine of the three bodies of the Buddha (Trikāya). Nichiren envisioned Japan as the land in which the true teaching of the Buddha was to be revived (hence the name *nichi* "sun" and *ren* "lotus"). Nichiren urged his followers to imitate the bodhisattva ideal of perseverence and self-sacrifice.

nise-e (J): "Realistic" painted portraiture, developed at the beginning of the thirteenth century in Japan by Fujiwara no Nobuzane, and fashionable in the thirteenth and fourteenth century. The portraits depicted court figures in formal pose, dressed in ceremonial robes; although the bodies and clothing were highly stylized, the countenances were individualized.

Pure Land. *See* Jōdo sect.

Ritsu sect (J: *ris-shū;* Ch: *lü-tsung*): One of the six sects of the Nara period. *Ritsu* literally meant *vinaya* (monastic precepts). The sect was founded by Tao-hsüan (Dōsen) of the T'ang dynasty in China, and it taught that the observance of the Mahāyānist precepts is the way to the attainment of Buddhahood. The teaching was transmitted to Japan by Ganjin in 754.

Śākyamuni (Sk; J: Shakamuni): The historical Buddha; born in Kapilavastu in the foothills of the Himalayas near Nepal around 563 B.C. His personal name was Siddhārtha and his family name Gautama. Because he was the son of a minor raja in a tribal state ruled by the Śākya clan, he was also called Śākyamuni, that is, sage of the Śākyas. At the age of twenty-nine the young prince abandoned the material world in order to meditate upon a way toward salvation. After six years he attained enlightenment while meditating under a sacred tree at Bodhgayā. He then defined his teaching, and in a series of sermons in the Deer Park at Benares he "set the wheel of the law into motion" by preaching the Four Great Truths, which were based on the idea that existence is an evil from which an escape can be found through practical means. He preached and wandered for the next forty-six years, attracting disciples wherever he went. He died at Kuśinagara in 483 B.C.

Samantabhadra (Sk; J: Fugen): The bodhisattva of universal virtue. The embodiment of the active practical aspects of Śākyamuni's doctrine. In art he is shown on one side of the historical Buddha with Mañjuśrī (Monju) on the other. In the final chapter of the *Lotus Sutra,* it is stated that Samantabhadra will mount his six-tusked white elephant and appear before the devotee to protect and teach him. The bodhisattva thus became known as the divine patron of the *Lotus Sutra* and its followers.

Sarasvatī (Sk; J: Benzai-ten): Female guardian and bestower of speech, eloquence, letters, and music. She is represented in two forms: one with two arms and holding a lute, and one with eight arms.

seed syllables (Sk: *bīja;* J: *shuji*): Syllables that replace a mantra, a word, or a symbolic object. Every aspect of any given Buddhist divinity has its seed syllable. The use of the *bīja* was highly developed in esoteric Buddhism.

shari (J; Sk: *śarīra*): Relics, especially of the historical Buddha.

Shin sect (J: *shin-shū*): The Jōdo Shin sect (literally, "True Pure Land sect"). A sect organized by the followers of Shinran, who believed that if salvation truly depended solely on Amitābha's grace, then one's state in life had no bearing on ultimate salvation. Shinran believed that his followers should identify with the ordinary man as much as possible, that monastic discipline was not essential to salvation, and that the family, not the monastery, should be the center of religious life. In the Shin sect, Buddhism was stripped of its accumulation of ritual and reduced to the simplest of faiths with Amitābha at its center.

Shingon sect (J: *shingon-shū*; Sk: *mantrayāna*): Literally, "True Word sect." Founded by Kūkai, who in 806 brought back the teachings of the Chinese master Hui-kuo to Japan. The name indicates the importance given to speech as one of the Three Mysteries: body, speech, and mind. The mysteries are transmitted orally from master to disciple. The cosmic Buddha Vairocana (J: Roshana) is the central deity of Shingon from whom all other beings emanate and who rules over a cosmos consisting of the five elements and consciousness. The Kongōbu-ji, built by Kūkai on Mount Kōya, became the center of the Shingon sect.

Shintō (J): Literally, "Way of the Gods"; the native Japanese religion. Shintō objects of worship are called *kami* and the central deity is the Sun Goddess Amaterasu-ōmikami. The oldest center of Shintō worship is at the Izumo shrine on the Japan Sea coast, but the shrine of the Sun Goddess at Ise is the most important. The arrival of Buddhism in the sixth century A.D. eclipsed Shintō until the early Heian period, when shrines were systematized, and the concept of *honji-suijaku,* in which Shintō deities were defined as avatars of Buddhas or bodhisattvas, was instituted. From the end of the Heian period, the ascendancy to power of men from the outlying provinces assured a more prominent role for the native religion, as opposed to court-favored Buddhism. After the 1274 and 1281 Mongol invasions, the Japanese with heightened national consciousness saw their deliverance in the intervention of the "divine winds" (*kamikaze*) which scattered the Mongol fleet. From the fifteenth century onwards, the Primal (*yuiitsu*) Shintō movement worked to reestablish Shintō as Japan's principal faith.

śūnya (Sk; J: *kū*): The void; empty, hollow, vacant, nonexistent. The doctrine that all phenomena and ego have no reality but are composed of a certain number of elements (*skandha*) which disintegrate.

sutra (Sk: *sūtra*; J: *kyō* [*gyō*]): The part of the Buddhist scriptures which contain the sermons attributed to the historical Buddha.

Taizōkai mandala (J: *taizōkai mandara*; Sk: *garbhadhātu maṇḍala*): The mandala of the Matrix World. In Shingon practice, the schematic representation of the cosmos in its fundamental aspect—the mantrix or universal source from which all things are produced. From Vairocana, the source of fundamental wisdom, at the center of the mandala, issue all the other manifestations of wisdom and power—Buddhas, bodhisattvas, and demigods. In Japan this mandala is placed in the east, typifying the rising sun as a source. The Kongōkai mandala and the Taizōkai mandala are the two principal mandalas of the Shingon sect.

Takenouchi no Sukune (J): A great statesman who was the prime minister of the Japanese empress Jingū (201–69), and who served under several successive emperors. He was later regarded as a Shintō *kami* (deity).

Tendai sect (J: *tendai-shū*; Ch: *t'ien-t'ai-tsung*): A sect established in Japan by Saichō, who brought back the T'ien-t'ai teachings from China. With the Lotus Sutra as its principal text, Tendai emphasized moral perfection rather than metaphysics. Tendai was patronized by Emperor Kammu until his death in 806. The center of the sect is Enryaku-ji, on Mount Hiei outside Kyoto.

Tuṣita (Sk; J: *tosotsu-ten*): The Tuṣita heaven is the fourth heaven in the realm of desire. At its core is the Pure Land of Maitreya, where the future Buddha resides until he descends to earth 584 million earthly years after the realization of nirvana by Śākyamuni.

vajra (Sk; J: *kongō-sho*): Literally, "the indestructible one," "a thunderbolt." In pre-Buddhist India, the thunderbolt was a weapon of the Hindu god Indra. Esoteric

Buddhism, notably the Shingon sect, ascribes to the *vajra* many symbolic meanings and various powers. In Shingon the most commonly used are the one-, three-, and five-pointed *vajra*s. The principal characteristic of the *vajra* is diamondlike hardness, symbolizing the indestructibility of the Buddhist Law. Because it embodies power, it also symbolizes sovereignty, and it frequently occurs in depictions of the Guardian Kings and of holy men.

vinaya (Sk; J: *ritsu*): The discipline or monastic rules, one of the three divisions of the Buddhist canon, the Tripiṭaka. The Ritsu sect is the teaching which emphasizes the Buddhist discipline.

yosegi-zukuri (J): Literally, "joined wood-block construction." A method of carving wooden statues in Japan in which a statue is made by carving its component parts separately, then joining them together. In the eleventh century the sculptor Jōchō established an assembly line system utilizing this technique whereby large statues were pieced together from small wood blocks. The interior would be practically hollow, making the finished statue light in weight. *Yosegi* became the principal technique in wood sculpture in Japan after the second half of the eleventh century.

Zen sect (J: *zen-shū;* Ch: *ch'an-tsung*): In China the practice of *dhyāna* (meditation), which is an integral part of most forms of Buddhism, came to serve as the basis of a separate school. According to tradition, Bodhidharma carried the teaching to China. Zen rejects both temporal and scriptural authority, and focuses attention on the master as the living embodiment of truth. In 1191 Eisai introduced the Rinzai (Ch: Lin-ch'i) or sudden enlightenment school of Zen to Japan, which emphasized the use of the *kōan,* an enigmatic theme upon which a student would meditate until a sudden realization brought him to enlightenment. Shortly thereafter, Dōgen introduced the Sōtō (Ch: Ts'ao-tsung) school from China, which eschewed the use of the *kōan* in favor of seated meditation *(zazen),* which, not focused on a specific problem, would lead to a gradual enlightenment.

BIBLIOGRAPHY

JAPANESE SOURCES

(selected by the author; annotated by the translator)

赤松俊秀「御影堂について」(『南都仏教』1)　[Akamatsu, Toshihide. "On the Miei-dō." *Nanto bukkyō*, no. 1].

浜田青陵「日本古代の肖像彫刻について」(『国華』214) 昭和22年　[Hamada, Seiryō. "On the Portrait Sculptures of Ancient Japan." *Kokka*, no. 214, 1947].

A brief survey of the development of portrait sculpture in Japan.

蓮実重康「奈良朝末期の二つの肖像彫刻」(『仏教芸術』23) 昭和29年　[Hasumi, Shigeyasu. "Two Portrait Statues of the Late Nara Period." *Bukkyō geijutsu*, no. 23, 1954].

Brief study of the statues of Ganjin in the Tōshōdai-ji and Gyōshin in the Yumedono at the Hōryū-ji.

『鎌倉の肖像彫刻』(鎌倉国宝館図録第八集) 鎌倉 鎌倉国宝館　昭和36年　[*The Portrait Sculpture of the Kamakura Period*. Eighth Collection of the Pictorial Records of the Kamakura National Treasure Museum. Kamakura: Kamakura National Treasure Museum, 1961].

A collection of photographs of significant works of Japanese portrait sculpture found mostly in Zen temples in the Kamakura area.

金森　遵「唐招提寺鑑真和上像」(『国宝』4–6)　[Kanamori, Jun. "The Statue of the Monk Ganjin in the Tōshōdai-ji." *Kokuhō*, vol. 4, no. 6].

小林　剛　肖像彫刻の項『彫刻』(日本美術大系) 東京 誠文堂新光社　昭和16年　[Kobayashi, Takeshi. "Portrait Sculpture." In *Sculpture*. An Outline of Japanese Art. Tokyo: Seibundō Shinkōsha, 1941].

Brief survey of the history of Japanese portrait sculpture.

―――「俊乗房重源の肖像について」(『仏教芸術』23) 昭和29年　[―――. "On the Portraits of Shunjōbō Chōgen." *Bukkyō geijutsu*, no. 23, 1954].

Article on the activities of Shunjōbō Chōgen and on his portraits in the Tōdai-ji in Nara, the Shiga Shindaibutsu-ji, the Jōdo-ji in Harima, and the Suo Amida-ji.

―――『肖像彫刻』東京 吉川弘文館　昭和44年　[―――. *Portrait Sculpture*. Tokyo: Yoshikawa Kōbunkan, 1969].

A detailed study of the development of portrait sculpture in Japan with observations on the major works of the genre and references to other works of note.

久野　健「万巻上人像について」(『日本史研究』20)　[Kuno, Takeshi. "On the Image of Mangan Shōnin." *Nihon-shi kenkyū*, no. 20].

倉田文作「奈良来迎寺の善道大師像」(『Museum』118)　[Kurata, Bunsaku. "The Statue of Zendō Daishi [Shan-tao] in the Raigō-ji in Nara." *Museum*, no. 118].

A brief study of the wooden statue of Shan-tao and its inscription and lacquered dais.

丸尾彰三郎「慈恵大師像のこと」(『史迹と美術』184) 昭和23年　[Maruo, Shōzaburō. "On Images of

Jie Daishi [Ryōgen]." *Shiseki to bijutsu*, no. 184, 1948].

A study of various representations of Ryōgen.

三山　進「頂相彫刻試論」(『美学』 17) [Miyama, Susumu. "Preliminary Essay on Zen Portrait Sculpture." *Bigaku*, no. 17].

毛利　久「唐招提寺影堂と鑑真像」(『史迹と美術』 225) 昭和27年 [Mōri, Hisashi. "The Portrait Hall of the Tōshōdai-ji and the Statue of Ganjin." *Shiseki to bijutsu*, no. 225, 1952].

A study of the establishment of the portrait hall and the enshrinement of Ganjin.

西川杏太郎『頂相彫刻』(日本の美術 123) 東京 至文堂　昭和51年 [Nishikawa, Kyōtarō. *Zen Portrait Sculpture*. Arts of Japan, no. 123. Tokyo: Shibundō, 1976].

A study of Zen portrait sculpture and its development in Japan.

西川新次「西照寺の親鸞御影像について」(『越佐研究』 16) [Nishikawa, Shinji. "The Statue of Shinran in the Saishō-ji." *Etsusa kenkyū*, no. 16].

佐和隆研「二軀の裸形弘法大師像について」(『仏教芸術』 22) 昭和29年 [Sawa, Ryūken. "On Two Unclothed Statues of Kōbō Daishi." *Bukkyō geijutsu*, no. 22, 1954].

A study of unclothed statues of Kōbō Daishi in Japan centering on the works in the Shōren-ji in Kamakura and the Saikō-ji in Nara.

杉山二郎「聖徳太子信仰とその造像」(『仏教史学』 12-1) [Sugiyama, Jirō. "The Cult of Shōtoku Taishi and Its Images." *Bukkyō shigaku*, vol. 12, no. 1].

若井富蔵「三井寺智証大師像及び其の模刻」上・下 (『史迹と美術』 79・80) 昭和12年 [Wakai, Tomizō. "The Statue of Chishō Daishi [Enchin] in the Mii-dera [Onjō-ji] and Its Copies." *Shiseki to bijutsu*, nos. 79, 80, 1937].

Detailed study of the Mii-dera Enchin and its role as a model for other images of Enchin.

FURTHER READING
(selected and annotated by the translator)

Elisséeff, Serge. "Notes Sur Le Portrait En Extrême-Orient." *Etudes d'Orientalisme* 1 (1932): 169–202.

A study of the development and function of portraiture in East Asia.

Friedlander, Max J. *Landscape, Portrait, Still-Life: Their Origin and Development*. New York: Schocken, 1963.

Treatise on the principal genres of Western art.

Hankmann, George M. A. *Observations on Roman Portraiture*. Brussels: Latomus, 1953.

Discussion of Roman portraiture centering on the portrait head of Lucius Verus in the Fogg Art Museum, Harvard University.

Kameda, Tsutomu; Tanabe, Saburōsuke; Nagai, Shin'ichi; and Miya, Tsugio. *Masks and Portraits*. Japanese Art in Color, vol. 23. Tokyo: Shogakkan, 1971. In Japanese. [亀田孜・田辺三郎助・永井信一・宮　次男『面と肖像』(原色日本の美術 23) 東京　小学館　昭和46年]

Color reproductions of significant Japanese portrait statues and an explanatory essay covering the span of Japanese portraiture. List of plates in English.

Kidder, J. Edward, Jr. *Masterpieces of Japanese Sculpture*. Tokyo: Bijutsu Shippansha and Tuttle, 1961.

A pictorial essay covering the high points in the development of Japanese sculpture with brief descriptions of plates and an explanatory paragraph on each major period of art.

Kuno, Takeshi. *A Guide to Japanese Sculpture.* Tokyo: Maruyama, 1963.

Text covers the major developments in Japanese sculpture, with a knowledgeable explanation of the significant artistic events in each period. A large number of plates.

Kokuhō: National Treasures of Japan. Vols. 1–6. Tokyo: Mainichi Newspapers, 1963–67.

Illustrations of sculptural masterpieces that have been designated National Treasures.

Moran, Sherwood F. "The Statue of Muchaku, Hokuen-dō, Kōfuku-ji: A Detailed Study." *Arts Asiatiques* 1 (1958): 49–64.

A technical study of the statue of Muchaku (alternately, Mujaku; Sk: Asaṅga), and a discussion of the pattern on the garment worn by the figure.

———. "The Portrait of Uesugi Shigefusa, Meigetsu-in, Kamakura." *Arts Asiatiques* 4 (1959): 283–96.

A technical study of the Kamakura-period statue of Uesugi Shigefusa.

Pope-Hennessey, John. *The Portrait in the Renaissance.* Princeton: Princeton University Press, 1967.

Discusses portraiture in the Italian Renaissance in terms of the ideas by which they were inspired rather than by type or format.

Rosenfield, John M. "The Sedgwick Statue of the Infant Shōtoku Taishi." *Archives of Asian Art* 22 (1968–69): 56–79.

A study of representations of Shōtoku Taishi as an infant, centering on one such statue in an American private collection.

Rosenfield, John M. "Studies in Japanese Portraiture: The Statue of Gien at the Oka-dera." *Ohio University Review* 5 (1963).

A discussion of the portrait of Gien, which is dated by some scholars to the Nara period and by others to early Heian.

Rosenfield, John M. "Studies in Japanese Portraiture: The Statue of Nichira." *Oriental Art,* n.s. 10, no. 2 (1964): 92–99.

Study on the early ninth-century portrait of Nichira, Illa (the) Talsol in Korean, now enshrined in the Tachibana-dera in the Asuka district.

Rosenfield, John M. "Studies in Japanese Portraiture: The Statue of Vimalakīrti at Hokke-ji." *Arts Orientalis* 6 (1966): 213–22.

Discussion of Vimalakīrti representations, centering on the statue in the Hokke-ji from the late Tempyō or early Heian period.

Tokyo National Museum, ed. *Sculpture.* Pageant of Japanese Art, vol. 3. Tokyo: Tokyo National Museum, 1953.

A survey of the best-known works of Japanese sculpture.

Warner, Langdon. *The Craft of the Japanese Sculptor.* New York: Japan Society, 1936.

A personal appreciation of Japanese sculpture, with observations on technique.

INDEX